T0047389

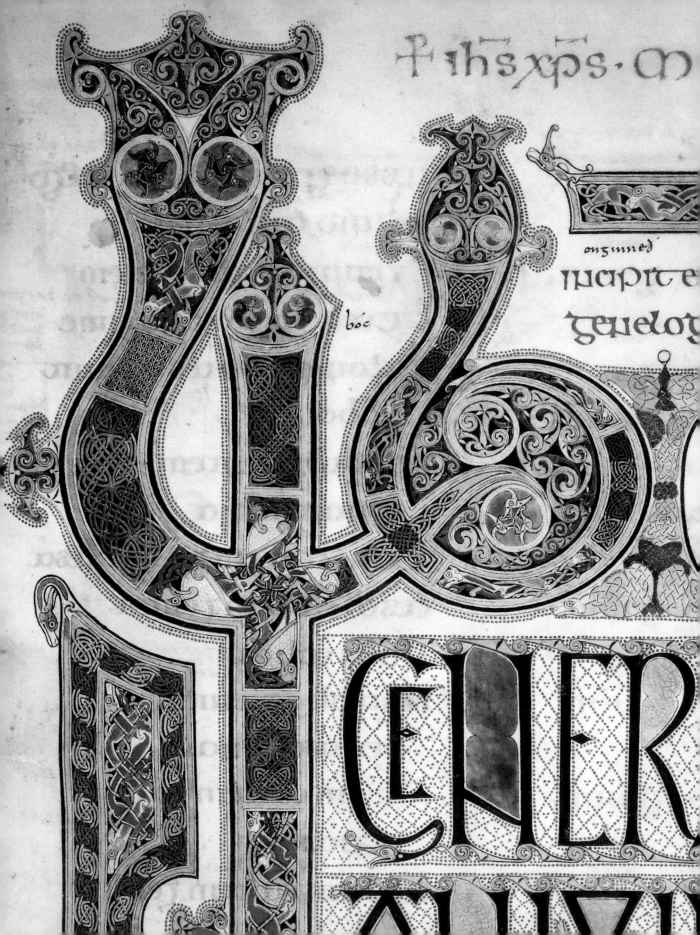

℞ ihs xps · m

onginned
incipit e
geneloȝ

THE LINDISFARNE GOSPELS

Art, History & Inspiration

THE BRITISH LIBRARY GUIDE

ELEANOR JACKSON

BRITISH LIBRARY

*This book is dedicated to the
memory of our friend and colleague,
Federica Micucci, 1989–2021*

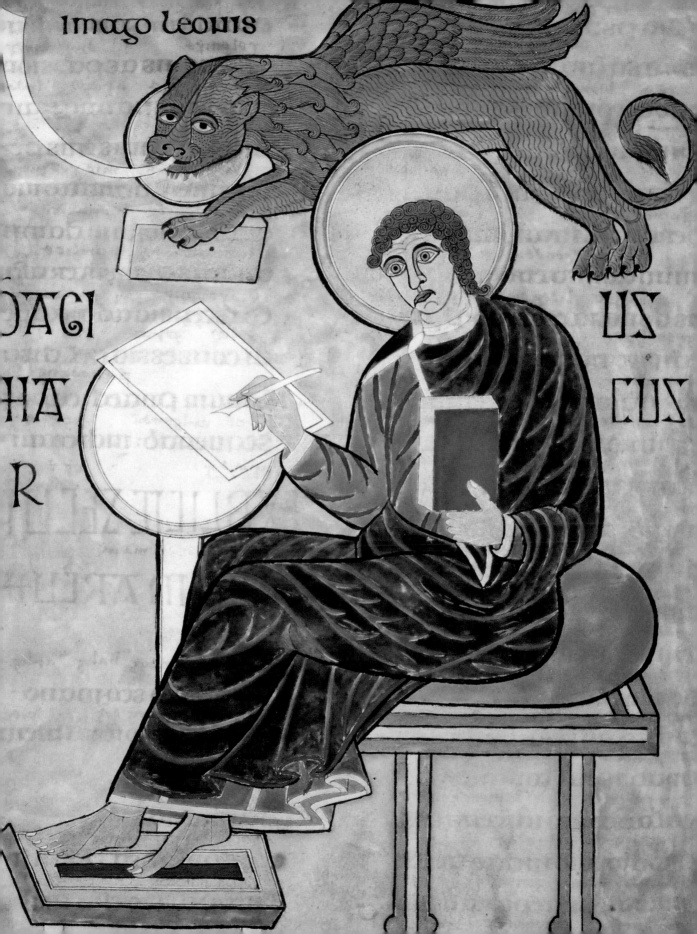

Imago Leonis

ƆACI
HA
R

US
CUS

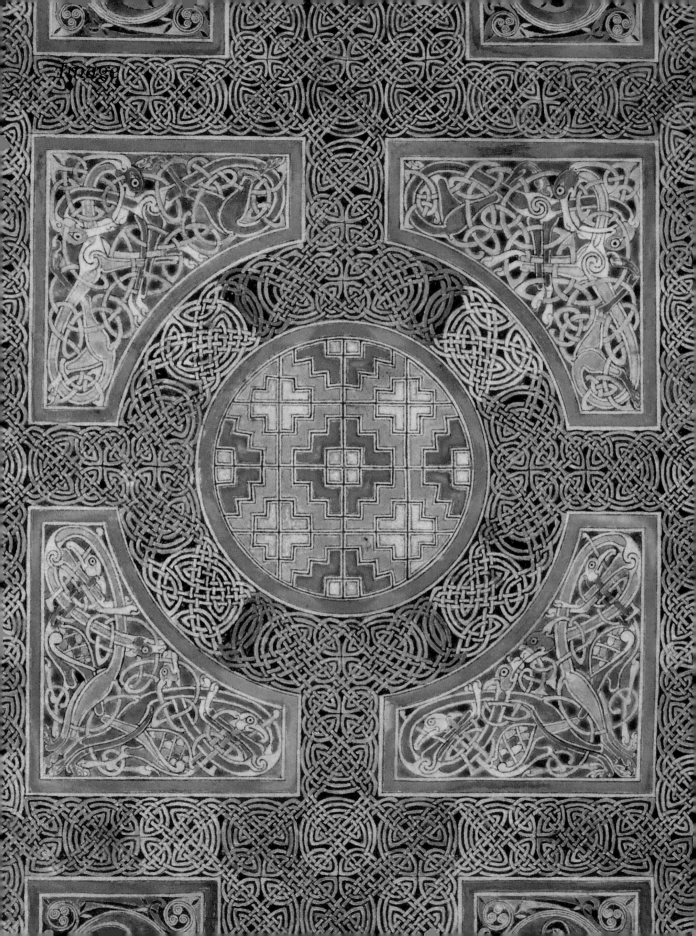

CONTENTS

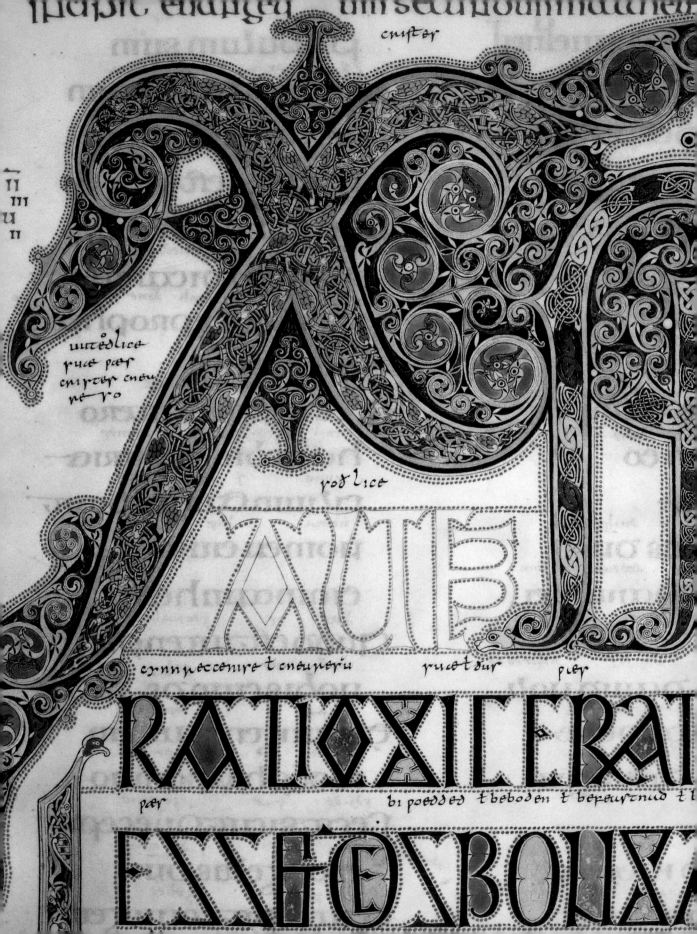

INTRODUCTION

The Lindisfarne Gospels is an extraordinary book. It was hand-written and decorated over 1,300 years ago by a single supremely gifted scribe-artist. It inspires awe both as a pinnacle of book design and for the fascinating story of how it came down to us. Every aspect of its design displays meticulous care, keen responsiveness to a wide range of cultural contacts, and the workings of an immense and brilliant imagination. It must have appeared as exceptional when it was made as it seems to us now. Certainly it has been treasured for the entirety of its existence and, despite its eventful history, it survives in near pristine condition.

Books written by hand are known as manuscripts, from the Latin *manus* ('hand') and *scriptus* ('written'). Until the mid-fifteenth century, all books made in Europe were manuscripts. The Lindisfarne Gospels is a manuscript of the four gospels, the biblical accounts of the life of Christ from the New Testament, in Latin. In the tenth century an Old English translation was added between the lines, which is the earliest surviving translation of the Gospels into the English language.

Gospel-books were the most important Christian books of the early Middle Ages. At a time when the entire Bible was rarely produced as a single volume, gospel-books were needed for daily readings in church as well as teaching and personal study. They were also revered as the physical word of God, often paraded in processions and displayed on the altar. Most were probably relatively plain working copies, but some were made for special devotional or ceremonial purposes. These were allocated the best materials and lavished with the utmost attention and creativity. Yet even among this group, the Lindisfarne Gospels stands out as exceptional.

[FIG.4] *Detail of the* Chi-rho *page (f. 29r).*

9

SETTING THE SCENE

CHAPTER 1

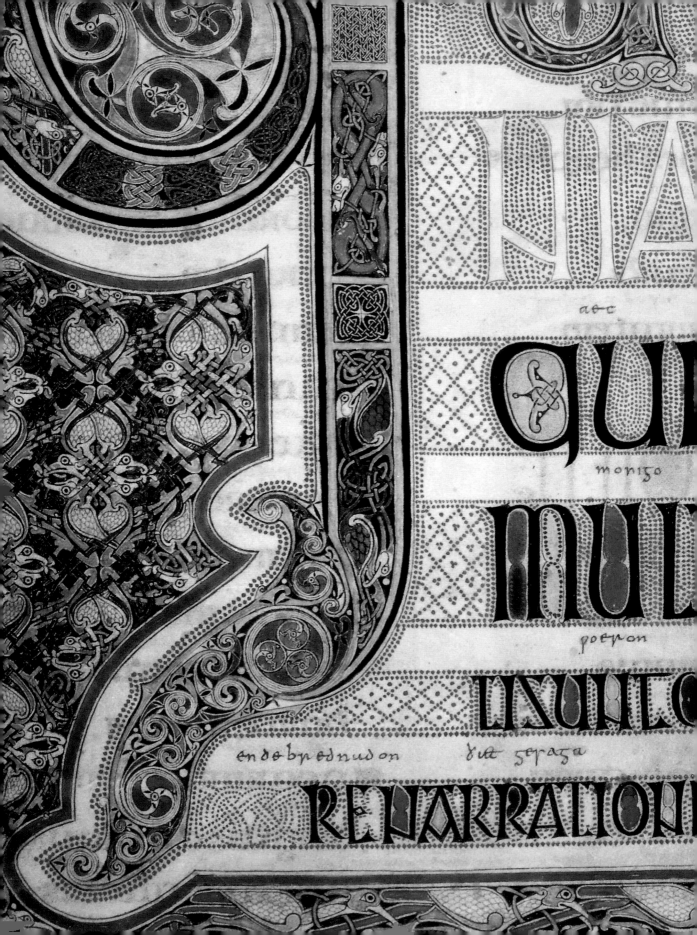

ΝΙΑ

aec

QUI

moniʒo

MUL

poepon

TISUILC

endobpednudon ꝺ̄ʆ ʒepaʒa

REΝΑRRATIOΝ

To understand how the Lindisfarne Gospels came into being, we have to go back to the historical circumstances of its production. The Lindisfarne Gospels originated at the ends of the earth, as the islands of Britain and Ireland were often characterised by early writers. From the perspective of post-Roman Europe, these were frontiers both geographically and culturally. Yet the spread of Christianity in England in the seventh century sparked a period of momentous change, bringing increased cultural interconnection, political and economic growth, and a fresh creative impulse, which propelled these lands to the forefront of Christian culture.

After the fall of the Roman Empire in the fifth century, the lands formerly under Roman control fragmented into a series of kingdoms. On the continent, these post-Roman kingdoms were mostly Christian, in union with the Roman Church. In Britain and Ireland, the situation was different. In Ireland, which had not been a part of the Roman Empire, conversion to Christianity had begun around the fifth century but the Church there had developed distinctive features due to its relative remoteness from the rest of Christian Europe. In Britain, there were groups of Christian Romano-British people who had remained after the withdrawal of Roman troops. However, from the fifth century they were displaced from large parts of the island following the arrival of Germanic-speaking settlers who had migrated from the North Sea coast of what is now Denmark, Germany and the Netherlands. These lands were beyond the fringes of Christian

[FIG.5] *Detail of the Gospel of St Luke* incipit *page (f. 139r).*

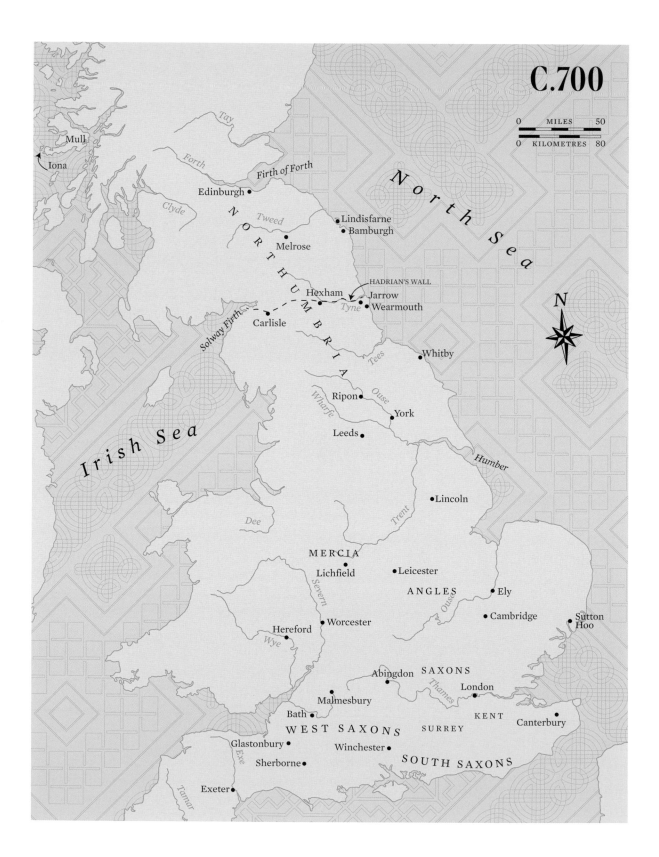

C.700

0 ————— MILES ————— 50
0 ————— KILOMETRES ————— 80

Mull
Iona

North Sea

Tay
Forth
Firth of Forth
Edinburgh •
Clyde
Tweed
Lindisfarne •
Bamburgh •
N O R T H U M B R I A
Melrose •
HADRIAN'S WALL
Hexham •
Jarrow •
Tyne
Wearmouth •
Carlisle •
Solway Firth
Tees
Whitby •

Irish Sea

Wharfe
Ripon •
Ouse
York •
Leeds •
Humber

Dee
Lincoln •
Trent
MERCIA
Lichfield •
Leicester •
ANGLES
Ely •
Severn
Ouse
Worcester •
Cambridge •
Sutton Hoo •
Hereford •
Wye
SAXONS
Abingdon •
Thames
London •
Malmesbury •
KENT
Bath •
WEST SAXONS
SURREY
Canterbury •
Glastonbury •
Winchester •
Exe
SOUTH SAXONS
Sherborne •
Tamar
Exeter •

N

[FIG.6, OPPOSITE] *Map of the early English kingdoms.*

[FIG.7, ABOVE] *Much of what we know about the history of England in this period is down to the historian and polymath Bede (d. 735), a monk at Wearmouth-Jarrow and author of the* Ecclesiastical History of the English People. *This copy of Bede's* Ecclesiastical History *was made in southern England in the first half of the ninth century (British Library, Cotton MS Tiberius C II, f. 5v).*

Europe, and the new settlers brought with them a pantheon of pagan gods. Some of the names of their gods are still enshrined in the English names for the days of the week: Tiw, Woden, Thunor and Frig.

By the seventh century, what is now England consisted of an unstable patchwork of kingdoms formed by these settlers. The people who lived in these kingdoms are often known as Anglo-Saxons because some of them were descended from the Germanic tribes called the Saxons and the Angles, but the term oversimplifies the true diversity of these groups. The kingdoms were ruled by kings who in reality were more like warlords, commanding retinues of loyal warriors and constantly fighting with one another to try to extend their territories. The concept of borders in the modern sense hardly applied, with the extent of each kingdom changing on a regular basis. Most people lived in farming communities and were expected to pay tribute to the king in return for protection. They spoke Old English, a precursor of modern English, which had developed from the Germanic languages of the settlers and encompassed a wide variety of regional dialects.

The story of the Lindisfarne Gospels takes us to the kingdom of Northumbria, literally the lands north of the River Humber, which at various times encompassed most of northern England and much of southern Scotland. The pagan people who inhabited Northumbria at the beginning of the seventh century had a culture based largely on oral transmission of knowledge. Books were probably more or less unknown to them. But the arrival of Christianity, a religion of the book, stimulated a period of fervent book collection and production in a few major centres. In the course of the seventh century, Northumbria grew in power, culminating in the period of heightened artistic and literary achievement sometimes known as the 'Golden Age of

Northumbria' (mid-seventh to mid-eighth century). This period saw the creation of many of the finest and most innovative books of their day. It is astonishing to think that, in only a few generations, Northumbria went from being virtually unaware of the technology of book design to producing the Lindisfarne Gospels. The conditions for such an achievement were produced by the unique mixing of cultures in Northumbria.

The rise of Christianity in Northumbria

One of the leading centres in this cultural transformation was the monastery of Lindisfarne, located on a small tidal island off the northeast coast of England. In 635, Oswald, king of Northumbria, granted the island to the Irish monk Aidan as a base for establishing Christianity in Northumbria. The new foundation was both a monastery and a bishop's seat, with Aidan as its first bishop. Aidan (d.651) had previously been a monk at the island monastery of Iona, off present-day Scotland. Founded by St Columba in 563, Iona was the religious centre of Dál Riata, a Gaelic kingdom spanning western Scotland and northeastern Ireland. Lindisfarne was established as a dependency of Iona and initially staffed mostly by Columban monks. Aidan and his companions travelled by foot around Northumbria, preaching to both rich and poor and establishing churches and monasteries.

But the Columban missionaries were not the only Christian influence that entered Northumbria in the seventh century. In 597, Pope Gregory the Great had sent a mission from Rome to convert England to Christianity. The missionaries established a base in Canterbury, which developed into a cosmopolitan centre of learning, attracting students and teachers from as far away as North Africa and the eastern Mediterranean. One of the Roman missionaries, Paulinus, led a mission from Canterbury to Northumbria around the year 625, but was forced to flee when Edwin, king of Northumbria, was killed at the Battle of Hatfield Chase in 633.

Nevertheless, once Aidan and his missionaries had effectively established Christianity in Northumbria, leading

[FIG.8] *Lindisfarne, including the ruins of the twelfth-century priory church which probably stands on the same site as its seventh-century predecessor (Skyscan/ Alamy Stock Photo).*

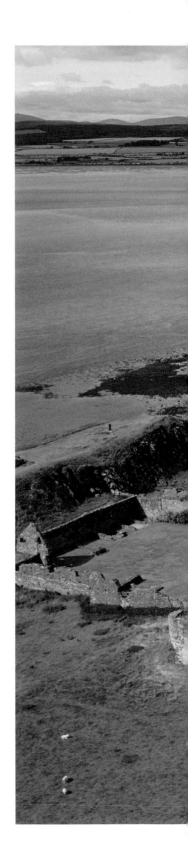

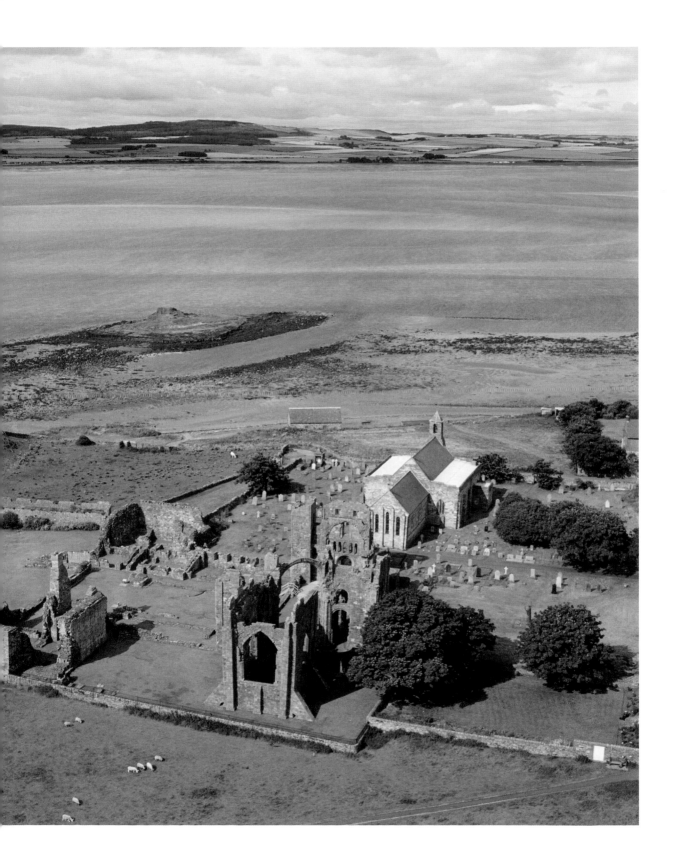

churchmen there soon turned their attention to Canterbury, and beyond that, to Rome. What they saw caused them to re-evaluate their own religious practice. The Columban traditions introduced by Aidan and his followers differed from those of the Roman Church in various ways. The most significant of these was the date for celebrating the most important festival in the Christian year, Easter. The difficulty arose because Easter is a moveable feast, which does not occur on the same calendar date each year. The Roman and the Columban traditions used different methods of calculating the date, so that in some years they would celebrate Easter on different days. This was painfully apparent in Northumbria where, by the 660s, practice was so drastically split that, even within the royal household, the king might be celebrating Easter while the queen was still fasting for Lent. The situation was at best inconvenient, and at worst dangerously divergent.

As tensions grew, the Northumbrian church agreed to hold a conference to settle the controversy. The Synod of Whitby took place in 664 at Whitby Abbey, hosted by Abbess Hild. King Oswiu of Northumbria presided over the debate. Making the case for the Columban side was Bishop Colmán of Lindisfarne (d.676), while representing the Roman side was Bishop Agilbert of the West Saxons, who appointed as his spokesman an up-and-coming young abbot, Wilfrid of Ripon (d.709/10). A Northumbrian by birth, Wilfrid began his education at Lindisfarne before travelling to Kent and then to the continent, where he stayed for extended periods in Lyons and Rome. After returning to Northumbria, he had been granted the monastery of Ripon where he introduced Roman practices and expelled the existing Lindisfarne-affiliated monks who refused to comply. At the Synod, the eloquent and combative Wilfrid overcame the arguments of Bishop Colmán, making a forceful case for aligning with the Roman church instituted by St Peter. King Oswiu sided with Wilfrid, concluding that he was not going to contradict the saint who held the keys to heaven.

The defeat at the Synod of Whitby was a great blow to the community at Lindisfarne. Colmán resigned his position as bishop and retreated to Dál Riata, along with all those who refused to comply with the Roman practices. From this point, Lindisfarne ended its dependency on Iona. The following decades were marked by a power struggle between the Lindisfarne faction and Wilfrid for control of the enormous

[FIG.9] *St Cuthbert preaching to the people of Northumbria, from a copy of the* Prose Life of Cuthbert *by Bede, made in the 4th quarter of the 12th century (British Library, Yates Thompson MS 26, f. 22v).*

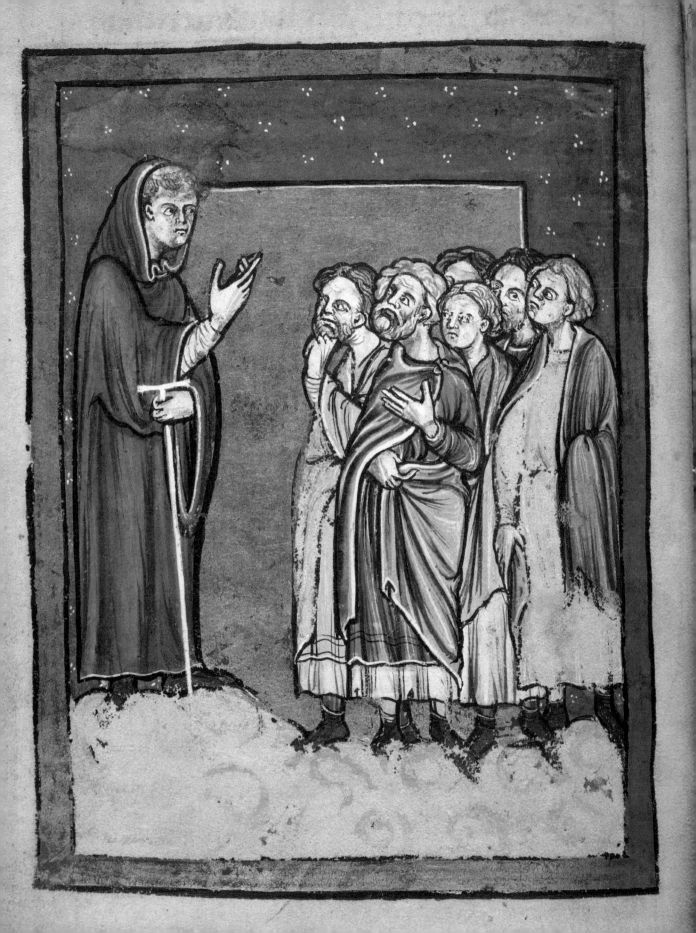

diocese of Northumbria. In this period, bishops wielded great political power and controlled large revenues from the lands in their dioceses, so the stakes in the conflict were high. These tumultuous years saw the bishop's seat transferred from Lindisfarne to York. Then the diocese was divided and replaced with bishops based in York, Lindisfarne and Hexham, thus restoring episcopal status to Lindisfarne.

The cult of St Cuthbert and the creation of the manuscript

In this period of instability, the Lindisfarne community needed a charismatic figure who could make peace between the factions and serve as a counterpoint to the divisive Wilfrid. They gained it in Cuthbert. A native Northumbrian of almost the same age as Wilfrid, Cuthbert began his monastic career at Melrose, a daughter-house of Lindisfarne, where he was grounded in Columban practice. He was among the group of monks who established the monastery at Ripon, before leaving when Wilfrid became abbot. Yet, after the Synod of Whitby, Cuthbert accepted Roman practice and was appointed to help establish the new customs at Lindisfarne. After some time, he withdrew to the tiny island of Inner Farne to become a hermit. There he lived in great austerity, fasting, praying, making prophecies and gaining a reputation as a great holy man. Despite his reluctance to leave his hermitage, Cuthbert became bishop of Lindisfarne in 685. He ruled for two years before falling gravely ill and returning to his hermitage on Inner Farne where he died in 687.

The monks of Lindisfarne brought Cuthbert's body back to their church and buried him in a stone sarcophagus. After Cuthbert's death, Wilfrid, who by now was bishop of Hexham, was also appointed bishop of Lindisfarne, much to the dismay of the community. After a difficult year, described by Bede in his *Life of St Cuthbert* as 'a blast of trial', a new bishop of Lindisfarne, Eadberht (d.698), was elected and 'the storms and disturbances were driven away'. Meanwhile, healing miracles started happening at Cuthbert's tomb. In 698, the monks transferred Cuthbert's body from his original grave to a raised shrine. At this point they discovered that his body was miraculously incorrupt, which they interpreted as a sure sign of sainthood. The monks placed the body in a chest, very probably the carved wooden coffin which survives to this day in Durham Cathedral (fig. 33). This enshrinement helped to establish St Cuthbert as the subject of a major cult.

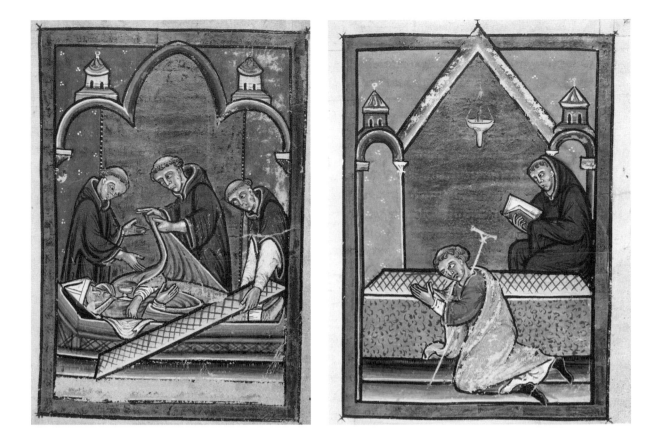

[FIG.10, LEFT] *The opening of St Cuthbert's tomb in 698 and the discovery of his incorrupt body, from a copy of the* Prose Life of Cuthbert *by Bede, made in the 4th quarter of the 12th century (British Library, Yates Thompson MS 26, f. 77r).*

[FIG.11, RIGHT] *A sick man being healed while praying at St Cuthbert's tomb, from a copy of the* Prose Life of Cuthbert *by Bede, made in the 4th quarter of the 12th century (British Library, Yates Thompson MS 26, f. 79r).*

Only a few months after the transfer of St Cuthbert's body to the new shrine, Eadberht died and was laid to rest in the sarcophagus in which Cuthbert had first been buried. The new bishop of Lindisfarne was Eadfrith (d.722), the man who is credited with writing the Lindisfarne Gospels 'for God and St Cuthbert and all the holy people who are on the island'. This information comes from a colophon, or inscription, written in the manuscript in the tenth century, which we will explore in more detail below (see pages 81–82). The implication is that Eadfrith created the manuscript in connection with the cult of St Cuthbert, perhaps to display on the altar by his shrine. Eadfrith certainly seems to have been proactive in advancing the cult: he restored Cuthbert's hermitage on Inner Farne and commissioned two accounts of Cuthbert's life, one written by an anonymous monk of Lindisfarne (around 700) and the other by Bede (around 720).

Eadfrith was succeeded as bishop of Lindisfarne by Æthilwald (d.740), previously abbot of Melrose, who, according to the

colophon, was responsible for binding the Lindisfarne Gospels. Æthilwald had known Cuthbert personally and contributed stories about him to the anonymous *Life of St Cuthbert*. The twelfth-century author Symeon of Durham reported that Æthilwald had a stone cross raised in memory of St Cuthbert.

It may also have been around this time that the Lindisfarne Gospels gained a finely crafted metalwork binding or case. The colophon records that precious ornaments of gold and gems were created for the manuscript by Billfrith the anchorite, a figure about whom little else is known. In the twelfth century, Symeon of Durham claimed that Billfrith ornamented the manuscript at the request of Bishop Æthilwald. He may be the same 'Bilfrith' who appears in the list of eighth-century anchorites in the Durham *Liber Vitae* ('Book of Life'), a manuscript which is thought to preserve the early records of the monastery of Lindisfarne (fig. 12).

As an anchorite, Billfrith would have led a life of self-discipline and isolation, either in the wilderness or in a cell. Encasing a manuscript in gold and gems might appear to be an unexpected project for one committed to such an ascetic lifestyle. Yet early medieval anchorites were usually supported by monastic communities and were regarded as figures of high status, with some Irish sources ranking them on the same level as a bishop. It was not unusual for churchmen to practise fine metalwork in the early Middle Ages, the most famous example being St Eligius, the seventh-century bishop of Noyon in France and patron saint of goldsmiths. The tradition of binding sacred texts in precious metalwork covers is attested from at least the sixth century. A surviving example is the pair of gold and jewelled

[FIG.12] *The name 'Bilfrith' in the list of eighth-century anchorites, written in alternating gold and silver ink in the* Durham Liber Vitae *(Book of Life), made around 840 (British Library, Cotton MS Domitian A vii, f. 18r).*

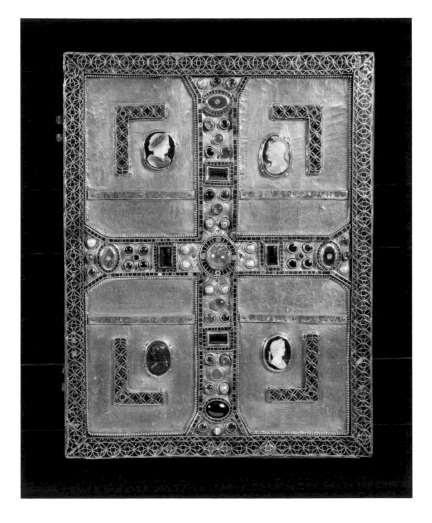

[FIG.13] *Book cover of Theodelinda, made in Italy in the late sixth or early seventh century (Museo e Tesoro del Duomo di Monza /photo Piero Pozzi).*

book covers donated to the basilica of St John the Baptist in Monza, northern Italy, by the Lombard queen Theodelinda in the late sixth or early seventh century (fig. 13).

Books and art in the 'Golden Age'

Meanwhile, the monastic culture of Northumbria was flourishing, giving rise to the 'Golden Age of Northumbria'. Supported by the kingdom's tremendous wealth and power, and energised by the influx of people, ideas and books, the Northumbrian church experienced an explosion of literary and artistic production. Written works from this period include Bede's *Ecclesiastical History of the English People*, Stephen of Ripon's *Life of St Wilfrid*, the anonymous *Life of Ceolfrith* from Wearmouth-Jarrow, and the anonymous *Life of Gregory the Great* from Whitby. In the

[FIG.14] *The Cathach of St Columba, a copy of the Psalter made in Ireland in the late 6th or early 7th century (Dublin, Royal Irish Academy, MS 12 R 33, f. 21r).*

visual arts, some of the most impressive survivals are the wooden coffin of St Cuthbert (fig. 33), the whalebone Franks Casket (now in the British Museum), and a series of magnificent stone-carved crosses such as those at Ruthwell in Dumfriesshire and Bewcastle in Cumbria. Not least, the period produced great manuscripts such as the Lindisfarne Gospels which, like the works of art in other media, creatively combined elements borrowed from different cultures and traditions.

The first books to arrive on Lindisfarne were probably brought from Iona by Aidan and his missionaries. They would have reflected the thriving scribal culture of Irish monasteries, exemplified by manuscripts such as the Cathach of St Columba, a Psalter made in Ireland in the late 6th or early 7th century (fig. 14). Ireland's relative remoteness from the rest of Christian Europe meant that book design there had evolved along different

lines from elsewhere. Irish scribes used distinctive scripts most likely derived from late antique manuscripts that had reached Ireland in the fifth century. Around the seventh century, Irish scribes introduced new graphic conventions, such as word separation and distinctive types of punctuation, to make reading easier. They also developed a new approach to decoration, morphing letters into decorative forms and endowing them with motifs from contemporary Irish metalwork. They were especially known for a decorative style called Ultimate La Tène, owing to its origins in the La Tène art of the Celtic Iron Age. This style consisted of graceful flowing patterns made up of trumpet and spiral shapes often ending in birds' heads. Enlarged letters at the beginning of a text were often followed by a scries of letters gradually decreasing in size, an effect known as *diminuendo*, which created a smooth visual transition from the initial to the main script. These distinctive characteristics suggest an increased awareness of the visual dimension of writing and its potential for creative expression.

Once Northumbria established links with the Roman Church, books of a very different kind started to appear. The Roman missionaries arrived in Canterbury bearing books and soon imported more. One of these, known as the St Augustine Gospels, still survives (fig. 17). Late antique books were brought to

[FIG.15] *St Peter's Church, Monkwearmouth, which preserves parts of Benedict Biscop's original monastic church in the tower and west wall (© Chemival/ Dreamstime.com).*

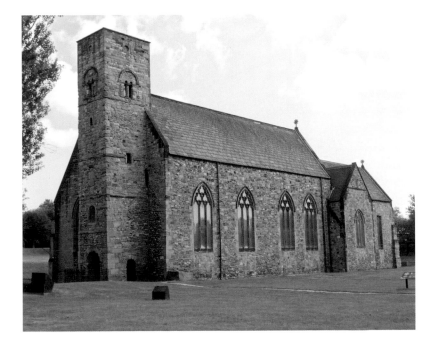

[FIG.16, LEFT] *The Harley Gospels, a copy of the Gospels written in uncial script and* per cola et commata *layout, made probably in Northern Italy in the late sixth century (British Library, Harley MS 1775, f. 114r).*

[FIG.17, OPPOSITE] *Evangelist portrait of St Luke in the St Augustine Gospels, made in Italy, possibly Rome, in the late 6th century (Cambridge, Corpus Christi College, MS 286, f. 129v).*

Northumbria from continental Europe by cosmopolitan figures such as the Northumbrian abbot Benedict Biscop (d.690). He made five trips to Rome and, in the words of Bede, 'brought back an innumerable abundance of books of every kind'. These he bestowed on the twin monasteries of Wearmouth-Jarrow, both in present-day Tyne and Wear, which he founded in around 673 and 681. This immense library sustained the wide-ranging work of Bede, who spent his entire adult life at Wearmouth-Jarrow. Biscop's successor, Abbot Ceolfrith (d.716), established a highly organised programme of manuscript production at Wearmouth-Jarrow inspired by the late antique Italian books in its library. These productions include such triumphs as Codex Amiatinus, the earliest surviving complete manuscript of the Bible in Latin (fig. 36), and the St Cuthbert Gospel, a small copy of the Gospel of John which was placed in the coffin of St Cuthbert (fig. 57).

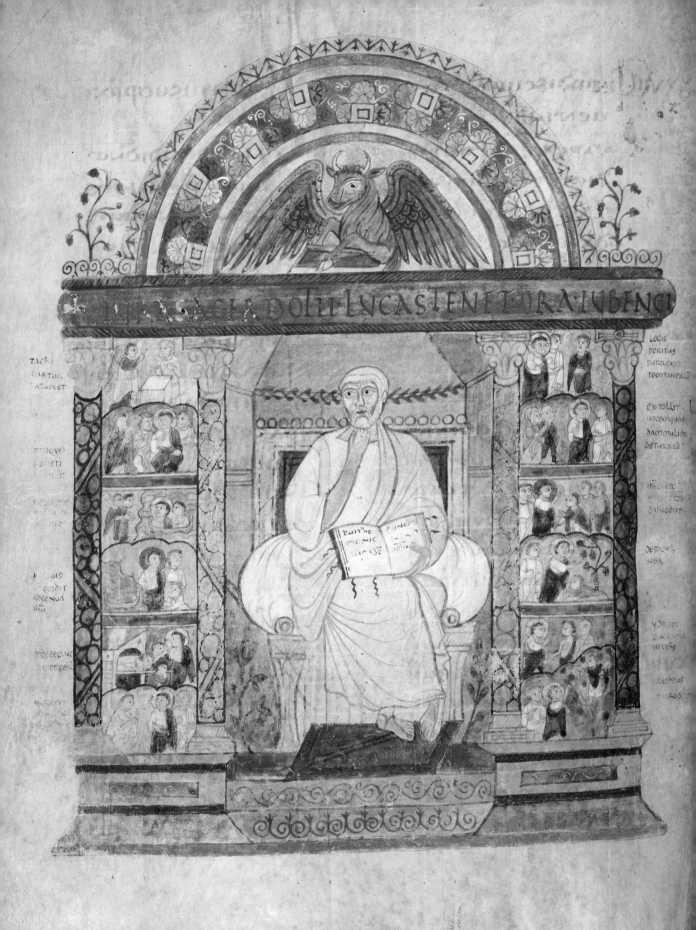

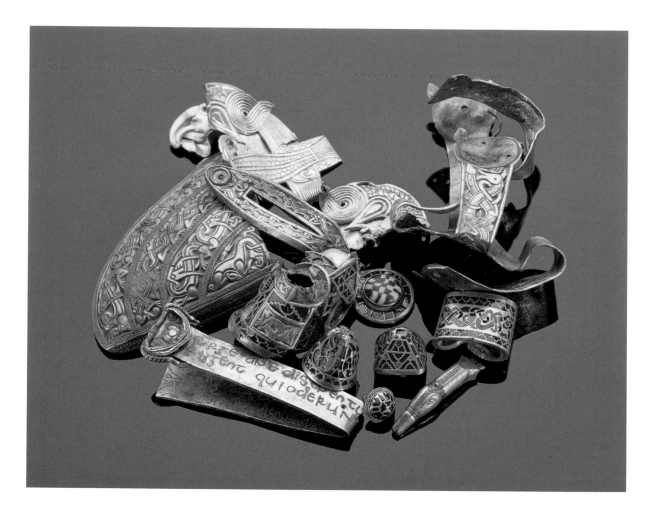

The late antique continental books imported to centres such as Canterbury and Wearmouth-Jarrow looked very different from the books from Ireland. They employed a stately script known as uncial, made up of broad rounded capital letters written continuously without spaces to distinguish one word from the next. The main form of punctuation was a system called *per cola et commata*, in which each clause or phrase began on a new line, a practice that was reserved for only the costliest biblical books owing to its extravagant use of parchment. The script had a graceful austerity, with little if any decoration. An example of such a manuscript is the Harley Gospels, probably made in Northern Italy in the late sixth century (fig. 16). Some of the grandest examples, such as the St Augustine Gospels (fig. 17), contained pictures in a style developed from classical Greek and Roman painting. They depicted figures in toga-like costumes, the

[FIG.18] *A selection of objects from the Staffordshire Hoard, made in England in the seventh century (Birmingham City Council and Stoke-on-Trent City Council).*

folds carefully draped to suggest the contours of the body, and employed painterly effects such as shading and highlighting to create a sense of depth. Decoration, when it was included, often consisted of sprigs of delicate foliage or architectural elements. With their distinctive classical features, these books encapsulated the prestige of Rome.

Yet the people of early medieval England also had strong visual traditions of their own. In common with the cultures of Germanic-speaking peoples on the continent, their art was based on stylised animal and bird forms. A favourite motif was animal interlace, in which elongated creatures intertwine to form a dense tangle of elaborate knotwork. They delighted in the effect of a seeming chaos of pattern which resolves into a balanced and harmonious composition overall. Their culture is known for its extraordinary accomplishments in metalwork, most famously the finds from the Sutton Hoo ship burial in Suffolk and the Staffordshire Hoard (fig. 18), featuring animal and interlace patterns intricately crafted in gold and garnets. This captivation with finely decorated metalwork is reflected in the descriptions of treasures in the Old English epic poem, *Beowulf* (preserved in a manuscript made around 1000). The mighty sword which the hero Beowulf retrieves from the lake is described as the 'work of wonder-smiths' (*wundorsmiþa geweorc*), its gold hilt 'twisted and ornamented with serpent patterns' (*wreoþenhilt ond wyrmfah*). The poem relates how King Hrothgar examines the wonderful hilt, perceiving stories and meanings in its decoration. This was an art that was made for thoughtful looking.

It was the combination of elements from each of these traditions, Irish, Roman and English, that laid the foundation for the production of the Lindisfarne Gospels. This hybrid early medieval culture is known as 'Insular', literally meaning 'of the Isles', to indicate its shared heritage in Ireland and Britain. The intricate melding together of elements from these traditions is one of the striking features of the Lindisfarne Gospels and can be seen in almost every feature of its design.

INSIDE THE LINDISFARNE GOSPELS

CHAPTER 2 ···

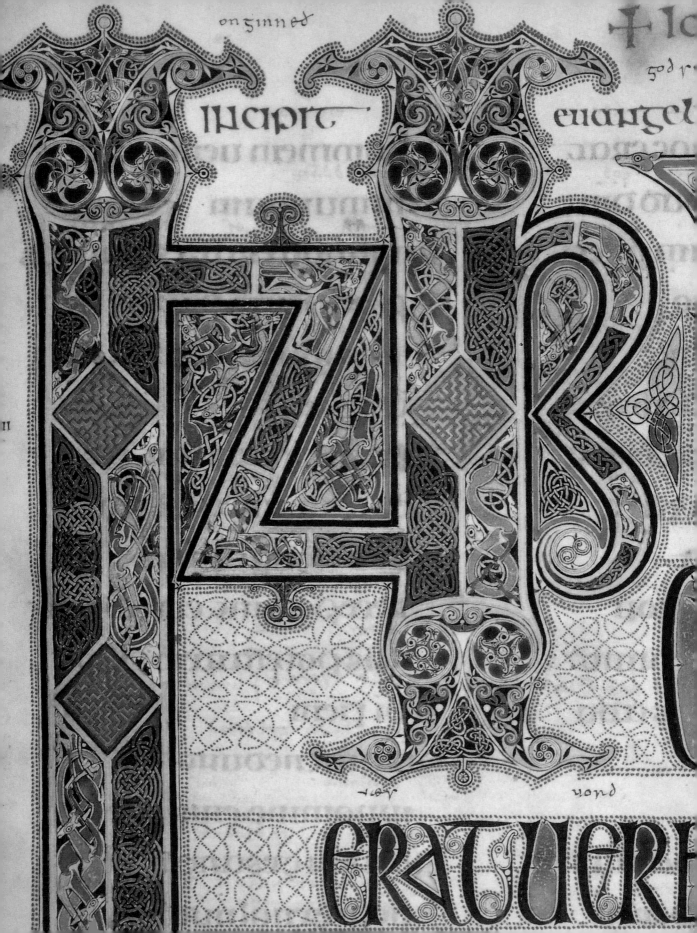

INCIPIT euangelia

LIZAB

ERUERE

The Lindisfarne Gospels is a breathtaking feat of skill and devotion. Standing at an important moment in the history of book design, it bears the fruits of the unique mixing of cultural influences that took place in seventh-century Northumbria. These include a particularly pure Gospel text, practical design features to improve ease of reading, as well as decoration that mesmerises with its brilliance and intricacy. There is a clear awareness that more than simply transmitting a text, a book can guide its reception in ways that might be thought-provoking, emotional or spiritual.

Scholarly analysis supports the view that, except for some titles and marginal apparatus, all the original script and decoration were carried out by one highly talented individual. According to the colophon, this was Eadfrith, bishop of Lindisfarne, who wrote it 'for God and st Cuthbert and all the holy people who are on the island'. It has been estimated that it may have taken him between five and ten years to complete the task. His precise geometry, sense of design and lively imagination show that he was supremely gifted as a mathematician, scribe, designer and artist.

The physical object
As a physical object, the Lindisfarne Gospels makes a magnificent impression (fig. 20). It has 259 leaves (or 518 pages, where a page is one side of a leaf), each measuring over 34 × 25 cm. This makes it larger than most modern-day books as well as most manuscripts of its period. But it is by no means the largest example. Codex Amiatinus, the great single-volume Bible from Wearmouth-Jarrow, has a colossal 1,030 leaves, each measuring

[FIG.19] *Detail of the Gospel of St John incipit page (f. 211r).*

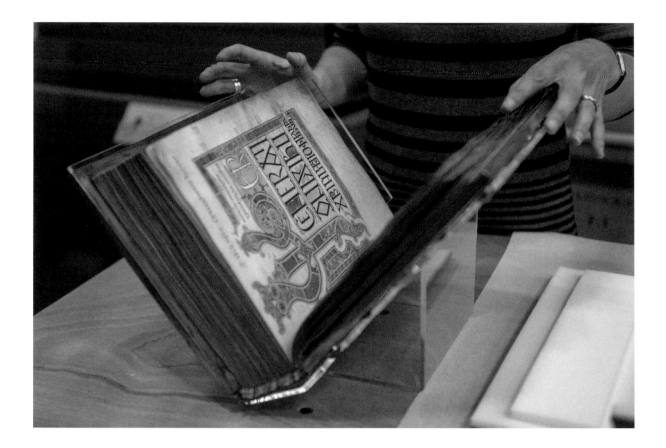

around 50 x 34 cm. In the Middle Ages, the appearance of the Lindisfarne Gospels would have been enhanced by the gold and gem-encrusted metalwork covers or case said to have been crafted by Billfrith (see pages 22–23 & 82–84). The date of the removal of these covers from the manuscript is not recorded, but an imposing silver-gilt and jewelled binding was added to the manuscript in the nineteenth century (see pages 86–87).

[FIG.20] *The Lindisfarne Gospels being prepared for display in the British Library's* Anglo-Saxon Kingdoms *exhibition in 2018 (© Sam Lane Photography).*

Materials

In early medieval Europe, books were written on pages of parchment, made from animal skin that had been scraped clean, stretched and dried. The parchment of the Lindisfarne Gospels is probably made from calfskin (also known as vellum), following Insular tradition. The Lindisfarne Gospels contains the skins of around 150 calves, reflecting the extensive resources that the community could draw on. The outstanding quality of the parchment and the lack of defects suggests that only the finest sheets were selected for the project.

Before the invention of synthetic pigments in the nineteenth century, all inks and paints were hand-made from natural sources, whether animal, vegetable or mineral. The Lindisfarne Gospels is written with iron gall ink, made from iron salts mixed with oak galls (tannin-rich swellings on oak trees). Silver- or lead-point was used for back-drawing some of the designs before painting. Scientific testing revealed that most of the materials used for the paints in the Lindisfarne Gospels could have been sourced in Britain and Ireland. The pigments include red lead (orange), indigo/woad (blue), orpiment (yellow), verdigris (green), carbon (black), white lead (white) and chalk (beige). This limited range of materials was expertly processed, mixed and applied in different ways to produce a brilliant array of shades and hues.

One of the most intriguing features of the Lindisfarne Gospels' palette is its use of gold, albeit in very small quantities. At the beginning of each gospel, the name of the evangelist and his symbol are written in gold ink, and tiny pieces of gold leaf are sometimes used as infill within the magnificent initial letters (fig. 21). Gold featured in luxury manuscripts from the late antique Mediterranean, but there is no evidence that it was used in Ireland in this period. The Lindisfarne Gospels' rich colours together with its use of gold suggest an ambition to emulate the many-splendoured hues of late antique painting.

[FIG.21] *A small triangle of gold leaf between the spiral decorations inside the bowl of the letter 'Q' on the* incipit *page of the Gospel of St Luke (f. 139r detail).*

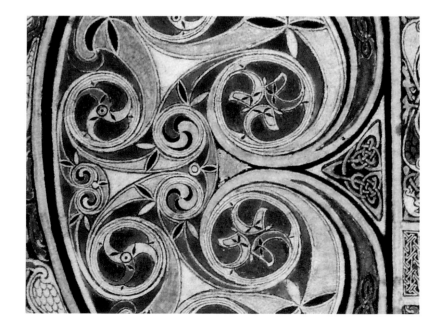

Text

The Lindisfarne Gospels contains the texts of the gospels, the four biblical accounts of the life of Christ, written by the evangelists, Saints Matthew, Mark, Luke and John. In the early Middle Ages, the books of the Bible existed in varying translations. The Latin text of the Lindisfarne Gospels is a particularly pure copy of the version known as the Vulgate. St Jerome completed the Vulgate translation of the gospels into Latin from the original Greek in the late fourth century. It was the beginning of a larger project to provide an accurate version of the Latin Bible for standard use in the Western Church. While the Vulgate did eventually become the dominant version, in the seventh century most gospel-books still preserved readings from pre-Vulgate texts, known collectively as the Old Latin Bible. The particularly pure Vulgate of the Lindisfarne Gospels closely matches the text used in Codex Amiatinus and the St Cuthbert Gospel, which were made at Wearmouth-Jarrow, the twin monastery founded and first stocked with books from Italy by Benedict Biscop. The close similarities between the Vulgate text of the Lindisfarne Gospels and these Wearmouth-Jarrow manuscripts suggest that Wearmouth-Jarrow lent a manuscript to Lindisfarne from which the text of the Lindisfarne Gospels was copied. The choice to use this unusual model shows the close relationship between Lindisfarne and Wearmouth-Jarrow, and may suggest a special esteem for St Jerome's Vulgate translation.

Vulgate gospel-books usually contain a set of supplementary texts intended to help the reader to understand and navigate the gospels, and the Lindisfarne Gospels is no exception. At the beginning of the whole book, there are two prologues by St Jerome, known by their first words, *Novum opus* ('New work'; (figs. 42, 52)) and *Plures fuisse* ('There were many'; (fig. 22)), and a set of canon tables (figs 30–31, 60), which are numbered lists of parallel or unique passages in the Gospels. At the beginning of each gospel, there is an individual preface and chapter list (figs 25–29, 61). In addition to these fairly standard elements, the Lindisfarne Gospels also has some unusual prefatory texts: before each gospel is a list of feast days on which passages from that gospel should be read (fig. 23). These include the feast days of St Januarius of Naples and the dedication of the Basilica Stephania in Naples, providing an essential clue that the exemplar manuscript probably had its roots in southern Italy. Curiously, the lists do not indicate which readings are required for each feast,

[FIG.22] *Opening of the* 'Plures fuisse' *preface (f. 5v).*

du pelle · hir · nægl

UOLUENS CUIUS CANONE

rie pona of hunden

SIT SCIAM EXSUBIECTO

num du geleceer

NUMENO DOCEBERIS

7 eft ge ann to dcem cnum

CONCURRENS ADPRINCI

mu in dcem talum

PIA INQUIB: CANONUM

hir gercéaden gerowna du + gironwnig

EST DISPUNCTA COUTENES

dee ilca te pona nim

EODEM Q; SCIAM CANONE

of tacon onpiones begeti synodecon

EXTAULO SNOTAS INUEOTO

hine dene du gerohter

ILLUM QUEM QUAEREBAS

nim der ilca

NUMERUM EIUS DEM

godypellener de 7 heróly

EUANGELISTAE QUI ETIPSE

of in priding gemencad hig

EXTUSCRIBTIONE SIGNAUIT

du menden ande of dcem cepiru

INUENIES ATQ; EUIANIA

odnum trumitu 7 pogum 7 trigu

CCETERORUM TRAMTAB:

in rcepunzum da tulo

INSPECTIS QUOS NULEROS

on erne hubug to

EREGIONE HABEANT AD

gemencu 7 midd; gepit du

NOTABIS ATQUIN SCIENS

eft ge lonn to hocum

RECURRES ADUOLUMINA

ruindnizum 7 buta

SINGULORUM ETSINE

twia ge pundena nimar

MONAREPERAS NUMERIS

da en du gebec nuder

QUOS ANTE SIGNAUERAS

on kindr 7 ytopa in An

REPPERIES ETLOCA INQUI

+ doilco + da cepteru

B: UEL EADEM UEL UICINA

ge cpoedun ie cearu dee menipt

DIXERUNT OPTO UTINXPO

ie onn

du getneoppacnig gemyndgu

UALEAS ET MEMINERIS

minn papu du eudgu

MEI PAPA BEATISSIME

EXPLICIT HIEROINIM

PRAEFATIO EIUSDEM

monige

PLURES

penun dade godypel

FUISSE QUI EUAN

las appiron

GELIA SCRIBSERUNT

7 ge godypellere

LUCAS EUANGELISTA

getnymmed cpoeden be

TESTATUR DICENS

fop don rodlice

QUONIAM QUIDEM

monige gecunnites rint

MULTI CONATI SUNT

ge en debnedege da rago

ORDINARE NARRATIONE

dinga da murie

RERUM QUAE INNOBIS

gefylled rindun ruie

COMPLETAE SUNT SICUT

gepal don ur

TRADIDERUNT NOBIS

dade pnomynum ma danco gere

QUI ABINITIO IPSIUIDE

gon pond 7 ge

NUNT SERMONEM ANI

em bihtatur him 7 deuh

UISRAUENUNTEI APER

punudun pid to ond

SEUENERUNT USQ; ADPNE

pond tit faftnunzu

SEUS TEMPUS MONUMEHA

beplice etbapdon da

DECLARANT QUAE

pid, pidenpondum lunpum

ADUENSIS AUCTORIB:

+ pnom

uindæ bebeadande

TERTIO COMMENDANS
mid hracing honda

EXTENSIONE MANUUM
tahte ⁊ him þa noter

SIGNIFICAT EI QUOD CRUCIS
deade yenteoyband mid droines

MORTE FORET MARTYRIO
seyisfertnad ...

CORONANDUS

quae lectio cum in natale

sci petri legitur.

a loco incoatur.

quo ait

Dicit simoni

petro ihs simon

iohannis

diligis me plus his

usq: ad locum ubi dicit

significans qua morte

clarificaturus esset dm

cum uero in natale sci

iohannis euangelistae in

choanda est a loco quo

ait dicit ei hoc est dns

simoni petro sequere me

usq: ubi dicit & scimus

quia uerum est

testimonium eius

EXPLICIT SECUDUM

iohannen

Sci iohannis

apostoli &

euangelistae

post epiphania

dnica prima

post ephifania dnica

secunda

inuelanda

in dedicatione sce mariae

Dnica ii xlgisma paschae

post octabas dni in ihu xpi

post iii dnicas de ephifania

de muliere samaritanae

De xlgisma feria iiii

in sci angeli & in dedicatione

sonas

coticliana

in natale sci andreae

coticliana

post iiii dnicas xlgisma

feria iiii

post iiii dnica xlgisma feria
iiii

making them unusable. Perhaps the scribe copied them out of reverence for the manuscript model and its far-flung connections.

Script

The main text of the Lindisfarne Gospels is written in a particularly fine example of the script known as Insular half-uncial (fig 23). This script originated in Ireland and was adopted and modified in England. The exemplar manuscript, whether from southern Italy or a Wearmouth-Jarrow copy, would almost certainly have been written in uncial script. Unlike uncial, Insular half-uncial is a four-line script, meaning that some letters have ascender strokes that rise above the body of the letters and others have descender strokes that go below. Also, in common with other Insular scripts, it features distinctive wedge shapes at the tops of the ascenders. This means that the scribe had the added task of mentally converting the uncial letterforms of the exemplar into the Insular half-uncial letterforms as he wrote. At the same time, perhaps inspired by the exemplar, he invested the Insular letters with some of the broadness, regularity and rotundity of uncial script. This suggests a careful effort to express the grandeur of late antique writing in a local idiom.

The punctuation of the script displays a similarly eclectic approach. The text is arranged according to the parchment-consuming *per cola et commata* system, most probably copied straight from the southern Italian exemplar. Yet Eadfrith also introduced the Irish practice of word separation, inserting a space after each word to distinguish it from the next. Further, he added enlarged letters with coloured infill and an outline of red dots to mark the beginnings of chapters, readings and other small units of text. These features demonstrate a concern to make the text easy to read and navigate.

Decoration

The concern to mark the divisions of the text is taken to extreme lengths in the glorious decorative scheme. There are thirty-one fully decorated pages in the Lindisfarne Gospels, as well as numerous smaller decorated letters. These pages are arranged according to a general programme of decoration established in Insular gospel-books, although they represent one of the most extensive and ambitious expressions of it. The book opens with a page of abstract pattern (a carpet page), facing a page of large decorated letters (an *incipit* page), at the beginning of St Jerome's

[FIG.23] *List of feasts with readings from the Gospel of St John. The Old English translation which was added between the lines of the Latin Gospel text in the tenth century was largely omitted on this page, so it gives a good impression of the original effect of the script and page design (f. 208r).*

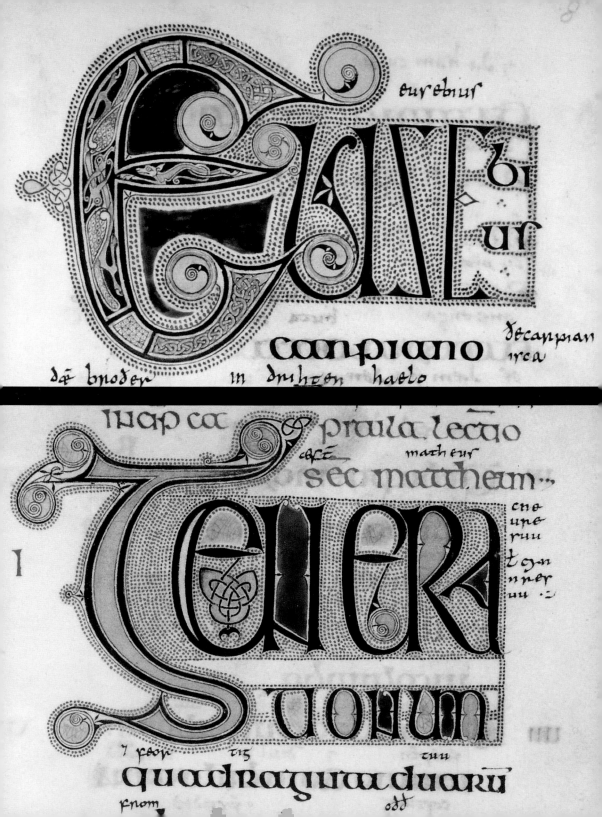

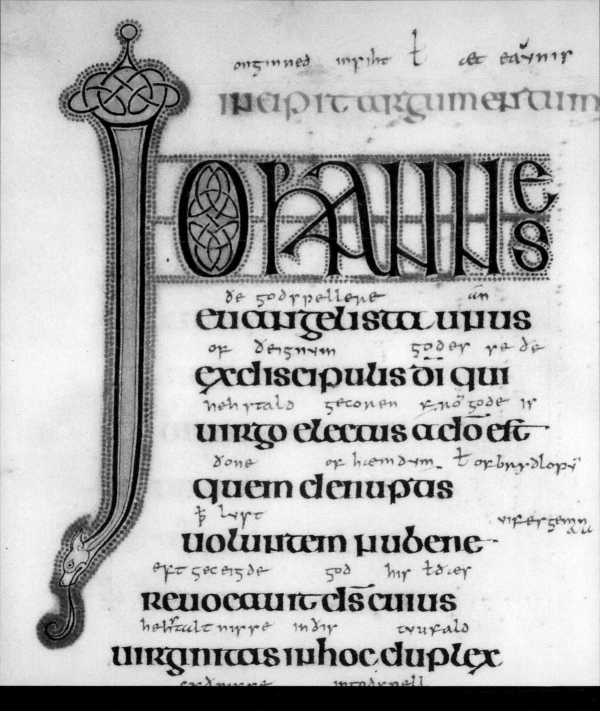

onginned incipit t et eaynir

incipit argumentum

Iohannes

de sodrpellene
evangelista uuus

of deignum soder rade
exdiscipulis di qui

nehrtalo geconen rnogode r
uirgo electus adso est

done of hæmarm. t orbny dlopi
quem denupsas

t hyr
uoluntam hubene

of geeigde sod hir toey
reuocauit dsculus

heltalt nyre indiy trufalo
uirginitas inhoc duplex

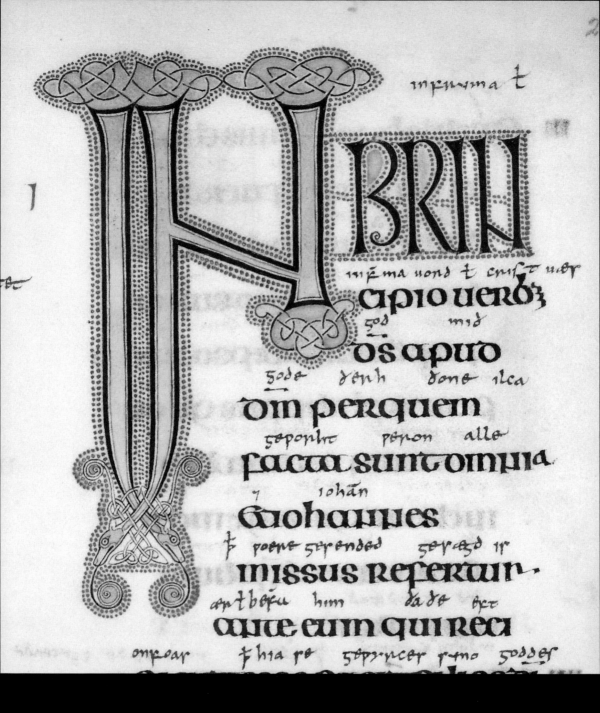

[FIG.27, ABOVE] *Decorated initial letters at the opening to the chapter lists to the Gospel of St John (f. 204r).*

[FIG.28, TOP] *Decorated initial letters at the opening to the preface to the Gospel of St Mark (f. 90r).*

[FIG.29, BOTTOM] *Decorated initial letters at the opening to the chapter lists to the Gospel of St Mark (f. 91r).*

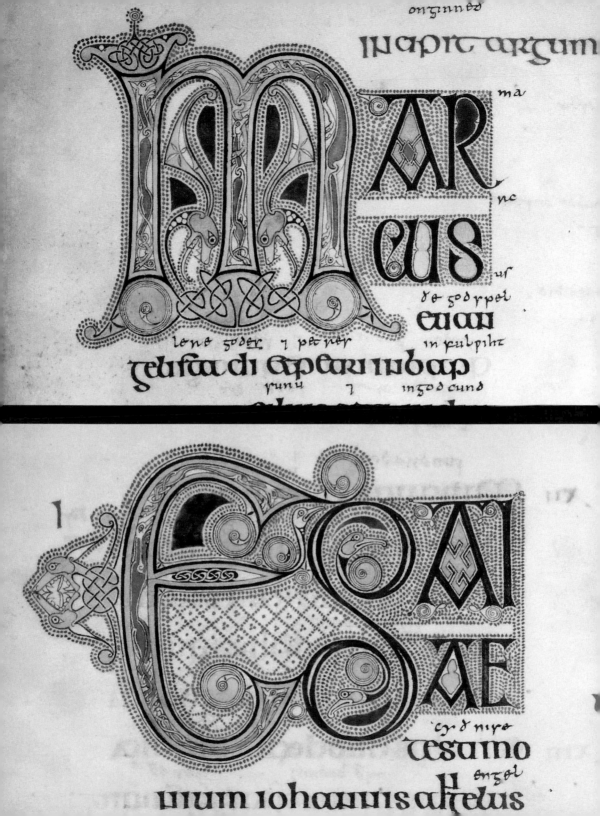

onġinneð

INCIPIT ARGUM

MAR ma
CUS nc

de gospel
euan
in fulpiht

lene sodep 7 pepep
ġeliffa di æpecrii mbaþ
runu 7 ingod cund

I E∇AI
SAE

cỹ ð niʒa
teſtimo
nium iohannis aþelus enʒol

Novum opus preface. Then come sixteen pages of architectural frames (the canon tables). Each of the four gospels opens with a monumental triad of decorated pages: a picture of the gospel-writer (an evangelist portrait), a carpet page, and an *incipit* page, on which the text of the gospel begins. In addition, the name of Christ at Matthew 1:18 is spectacularly enlarged and decorated (the *Chi-rho* page).

The general principle of this programme is to mark the beginning of texts with decoration, distinguishing the most significant junctures with the most profuse embellishment. On the one hand, this use of decoration serves a practical purpose. These eye-catching pages help the reader to locate the beginning of a text in an instant. On the other, the rich designs draw readers in, challenge them to interpret their meanings, and guide viewers' perceptions. The decoration creates a structure around the text, which leads the reader inside and builds a sense of journey over the course of the book. Like title pages, the decorated pages help to signal the subject of the following text and suggest ways of understanding it. In doing so, they play an important role in shaping the act of reading as a spiritual experience.

Canon tables

Before the beginning of the gospels themselves, there is a series of sixteen pages that are decorated with stylised architecture of columns and arches with writing in between (figs 30–31, 60). These are the canon tables, an apparatus for the study of the gospels devised by Eusebius of Caesarea in the early fourth century and included by St Jerome in his Vulgate translation of the gospels. The purpose of the canon tables was to show the sections of text in each gospel that have parallel passages in the other gospels and those that are unique to a single gospel. The modern division of the Bible into chapters and verses did not then exist, so Eusebius designed a system dividing the text into numbered units. These numbers can be seen written in the margins of the gospel text, next to the appropriate passage. Studious readers could then look these up in the canon tables, where the numbers are listed in columns, with parallel passages from the other gospels in the corresponding row.

This concern with the correspondences between the gospel texts implies another, deeper purpose for the canon tables: to demonstrate the harmony of the gospels. The impressive lists of parallel sections demonstrate that, despite being four separate

[FIG.30, OPPOSITE] *Canon table comparing parallel passages that occur in all four gospels (f. 11r).*

[FIG.31, FOLLOWING] *Canon table comparing parallel passages that occur only in the gospels of Sts Matthew, Mark and Luke (ff. 11v-12r).*

CANON BRIMUS INQUO QUATTUOR

MAT	MAR	LUC	IOH

ccxc	ccxci	ccxciii	lxxiiii
ccxci	ccxciii	ccxciii	clxvii
ccxciii	ccxci	ccxci	clxviii
ccxciii	ccxci	ccxci	clxxii
ccxcii		ccxci	
ccxciiii	ccxciii	ccc	clxxii
ccxx	cc	cccii	clxxiiii
ccxciii	ccliii	ccxc	clxxiii
ccxciii	ccii	ccxci	clxxxiii
ccxcii	ccii	ccxciii	ccxci
ccxciiii	ccii	ccxciii	ccxci
ccxcvi	cclii	ccliiii	ccxci
ccxxxvi	ccxc	ccliii	cci
ccxxxvii	ccxc	ccxci	
ccxxxvii	ccxciii	ccxciii	ccxciiii
ccxxxvii	ccxci	ccxci	ccxciii
ccxxvi	ccxci	ccxcxviii	ccliii
ccxciii	ccxciii	ccxci	ccii
ccxciiii	ccxciii		
ccxciiii	ccxxxviii	ccxxxviii	cciii
ccliii	ccxxxvii	ccxciiii	cciii
ccliii	ccxci	ccxciii	ccxci

ANTE CANON BRI HUS

IN QUO QUAT TUOR

CANON SECUNDUS
INQUO TRES:

MAT · MARC · LUC

MAT	MARC	LUC	
xii	ii	xii	
xxi	x	xxxiii	
xxvi	cii	clxxxii	
xxvii	xxxviiii	ccccii	
xxvii	xxxxiiii	lxviiii	
l	xlv	liii	
lvii	lvi	iiii	
lxi	lvi	xxiii	
lxi	lxviiii	xxxiii	
lxvii	lxx	lxxix	
lxviiii	clviii	lxxxiii	
lxxi	xci	xxxiii	
lxxii	lxii	xxxviii	
lxxii	lxii	lxxxiii	
lxxiii	lxxx	xl	
lxxiii	liiiii	lxxvi	
lxxvi	lii	clxvii	
lxxviii	lxxiii	lxxvi	
xxxx	xxx	xliiii	
xxxxi	iiii	lxxxviii	
lxxxi	liii	xx	
lxxxii	liiii	lxxxviii	
lxxxiii	liiii	cxi	
lxxxiii	lii	cxii	
lxxxii	lii	lxxviii	
lxxxviii	ccii	ccliiii	
lxxxviii	ccii	ccli	
xci	xl	lxx	
xxxx	lxxxiii	xciiii	
xciiii	lxxxii	ccliii	

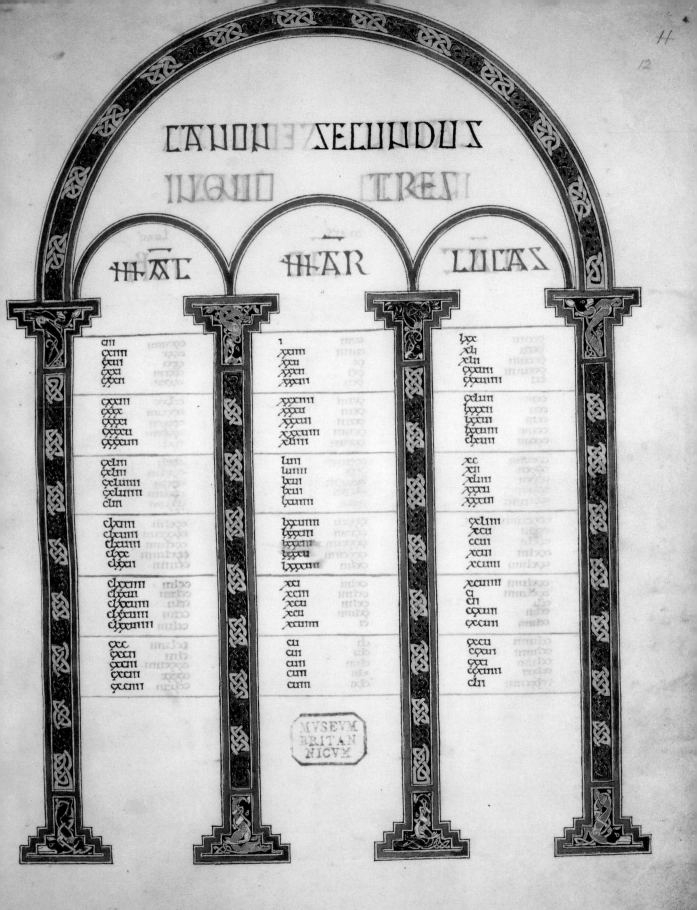

accounts, the gospels are consistent witnesses to the life and teachings of Christ. In the Lindisfarne Gospels, the graceful architectural decoration of the canon tables emphasises this sense of harmony. The lists of section numbers for each gospel are placed between the columns of an elegant arcade, each labelled with the name of the gospel in angular capitals. These are all embraced by a single large arch, labelled with the table number, to form a symmetrical structure. The columns and arches are based on classical architecture, their arrangement bringing to mind the apse of a late antique basilica. They are filled with brightly painted designs of interlaced animals, knotwork and fretwork from the repertory of Germanic art, perhaps suggesting the sorts of decoration that was found in churches in early medieval England. The overall effect is of stateliness and balance, a majestic temple to house the gospel.

Evangelist portraits

The first major decorated page at the beginning of each gospel is a portrait of the evangelist, the text's human author (figs 2, 32, 34, 35). This feature is borrowed from late antique illuminated gospel-books like the St Augustine Gospels (fig. 17). Such images are ultimately based on the classical author portraits that sometimes headed literary and philosophical texts in the ancient world. These portraits celebrated the author and assured the reader of the established authority of the text. In the Lindisfarne Gospels, the evangelists are depicted as distinguished authors of the late antique world. They each sit on an elegant painted bench with their gospel before them. They wear classically draped robes in rich colours with the folds outlined in a contrasting colour, giving the appearance of shot silk. With their delicate sandals, they are clearly dressed for a balmy Mediterranean climate. Their large halos signal their holiness and their wide almond-shaped eyes have a striking intensity. Each figure is labelled in a peculiar mixture of transliterated Greek, *O Agios* ('Saint'), and Latin, *Mattheus*, *Marcus*, *Lucas* and *Iohannes* ('Matthew', 'Mark', 'Luke' and 'John'), inscribed in angular Roman capitals. The attempt at Greek, a language that was little known in early medieval Northumbria, was probably intended to evoke the sanctity of the original language of the gospels.

The evangelists Matthew, Mark and Luke are all shown writing. In each case, the form of the gospel and the evangelist's interaction with it are different: Matthew writes in a book;

[FIG.32] *Evangelist portrait of St John (f. 209v).*

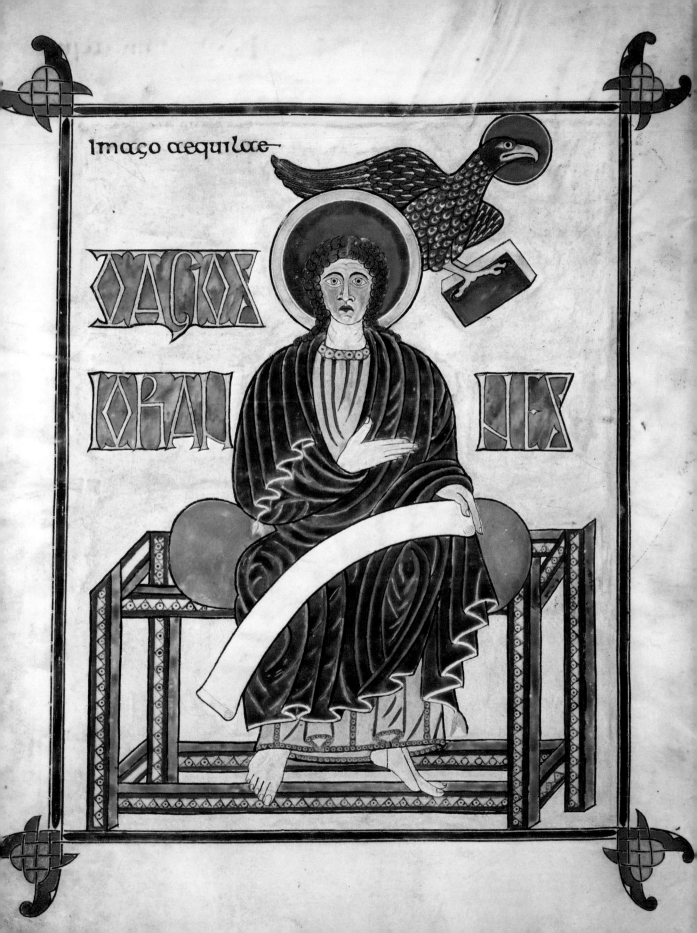

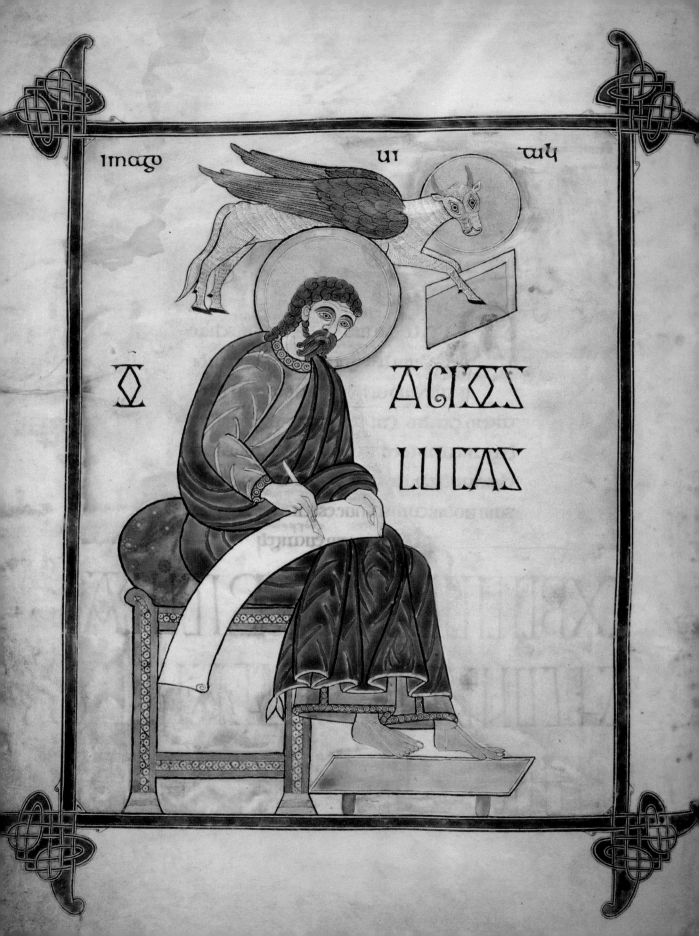

imago ui tul

AGIOS

LUCAS

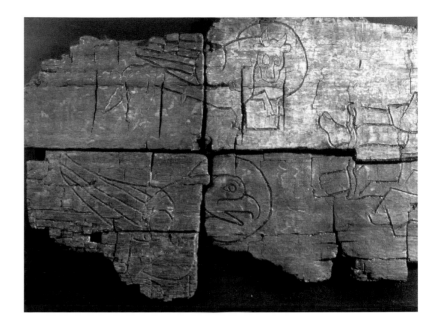

[FIG.33, RIGHT] *St Luke's Evangelist symbol the ox carved on the wooden coffin of St Cuthbert, made probably at Lindisfarne at the end of the seventh century. There are clear stylistic similaities to the winged and haloed bull, holding a book between its front legs, which appears as the symbol of St Luke in his Evangelist portrait (Durham Cathedral).*

[FIG.34, OPPOSITE] *Evangelist portrait of St Luke (f. 137v).*

Mark writes on a sheet while holding a closed book to his chest; Luke writes on a scroll. John does not write but gestures to the unfurled scroll on his lap. The images of books suggest a link between the original gospel texts written by the evangelists and the text of the Lindisfarne Gospels, as though promising authentic transmission from the evangelist's pen to the pages of this manuscript. The variation in the depictions also gives them a sense of individuality, suggesting different people writing in different ways.

The individuality of the evangelists is also emphasised by other distinctive features in the portraits. For example, each evangelist's hair and beard are a different style and colour. One particularly puzzling feature in the Matthew portrait is the presence of a haloed man who emerges from behind a curtain holding a book. His identity has been much debated, with suggestions including God, Moses, a representation of the Old Testament, an embodiment of every Christian believer, and St Cuthbert. The figure's identity may be left deliberately ambiguous to encourage readers to ponder the various possible interpretations. Another distinctive feature is that John is the only evangelist who sits frontally and fixes the viewer with an intense direct stare. This might reflect his status as a visionary, whose gospel starts with the Creation of the world 'In the beginning', and who was also believed to have described the end

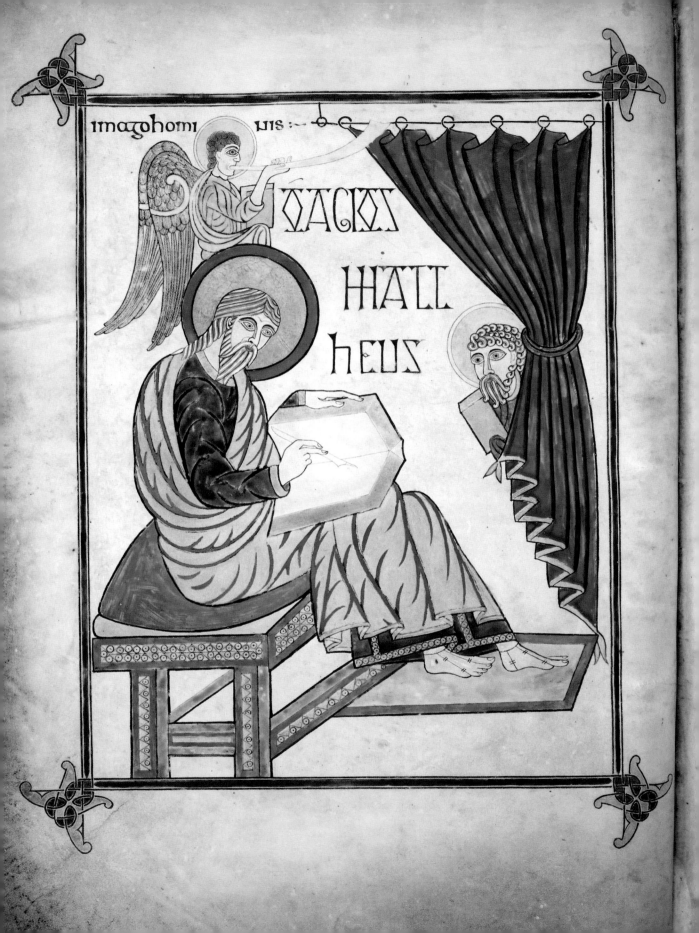

of the world in the Book of Revelation.

Above each evangelist there is a winged and haloed being clasping a book. These are the evangelist symbols, symbolic creatures that the early Church Fathers assigned to each of the four evangelists based on the visions of the four living creatures witnessed by Ezekiel and St John in the Bible (Ezekiel 1:5–28; Revelation 4:6–8). They are: the man of St Matthew, the lion of St Mark, the calf or ox of St Luke, and the eagle of St John. Each one is labelled in Latin, *Imago hominis* ('image of the man'), *Imago leonis* ('image of the lion'), etc. The symbolic creatures were used by early theologians to demonstrate that, in contrast to the many apocryphal gospels, the four evangelists and their books were divinely ordained within the canon of scripture. The presence of the symbolic creatures in the evangelist portraits is thus a further assurance of the authority of the text. The representations of the creatures are notably like that of the evangelist symbols on the lid of St Cuthbert's coffin, thought to have been carved for the transfer of the saint's body to the new raised shrine in 698. The rare depiction of St Luke's symbol as a winged and haloed bull holding a book between its front legs is especially similar (fig. 33).

The figures in the Lindisfarne evangelist portraits apparently derive from a late antique source, creatively reworked by the artist. Codex Amiatinus, the great single-volume Bible made at Wearmouth-Jarrow in the early years of the eighth century, contains a picture of the Old Testament prophet Ezra which is nearly identical in pose to St Matthew in the Lindisfarne Gospels (fig. 36). The two images almost certainly share the same or a related model, probably an illustration of a scribe in one of the Italian manuscripts in the library of Wearmouth-Jarrow. Yet whereas Codex Amiatinus adopts late antique painterly effects such as illusionistic three-dimensional space, shading and highlights, the Lindisfarne Gospels replaces them with flatness and linearity. The scene in the Matthew portrait does not make sense as a three-dimensional space: for example, St Matthew's feet and footrest appear to be floating in mid-air in relation to

[FIG.35, OPPOSITE] *Evangelist portrait of St Matthew (f. 25v).*

[FIG.36, ABOVE] *Portrait of Ezra from Codex Amiatinus, made at Wearmouth-Jarrow before 716 (Florence, Biblioteca Medicea Laurenziana, MS Amiatino 1, f. Vr).*

the bench. Instead, the restless folds of drapery, the neat locks of hair and the bold but rather disjunctive composition translate the scene into a series of dynamic patterns.

Carpet pages

The tendency towards pattern as a means of expression reaches new heights in the next decorated page at the opening of each gospel as well as the *Novum opus* preface. Facing the first page of text is a page entirely devoted to abstract ornament — a feature known as a carpet page (figs 37–38, 42–46). The origins of carpet pages are unknown. Some scholars suggest that they might have originated in Coptic Egypt. Yet the earliest surviving examples come from Insular contexts, and certainly, Insular artists developed them in a way that was distinctively their own. In the Lindisfarne Gospels, each carpet page contains a rectangular frame with decorated finials at the corners. The area within the frame is dominated by a magnificent cross-shaped design, laid out with great geometrical precision. The space inside the frames and crosses is covered with intricate patterns including interlace, bird and animal ornament, curvilinear trumpets and spirals, fretwork and stepped designs. Yet beyond these commonalities, each one is completely different and highly imaginative in design.

For example, the carpet page of the Gospel of Matthew (figs 37 & 43) features a Latin cross outlined in red, with arms expanding out into chalice shapes. The entire space inside the frame and the cross teems with finely wrought animal interlace. The area outside the cross is filled with entangled birds and dog-like creatures, their mouths firmly locked around one another's bodies as though engaged in an eternal skirmish. Inside, the cross contains only the dog-like creatures. The outside and inside of the cross are also distinguished by different colour palettes, mostly blue and pink outside and red and green inside. It is an exciting mental challenge to disentangle the forms, to work out which distended claw or elongated tail feather belongs to which creature, to trace the extent of a beast from its alert little face, along the twists and turns of its sinuous body, to the tips of its exaggerated claws. Within the dense weave of interlace, there is a captivating play between symmetry and asymmetry. While the general arrangement of beasts appears to be symmetrical along the vertical axis of the page, the order of the interlace is in fact reversed – so where a strand goes underneath on one side, the corresponding strand goes over the top on the other side. In the

[FIG.37] *Detail of the Gospel of St Matthew carpet page (f. 26v).*

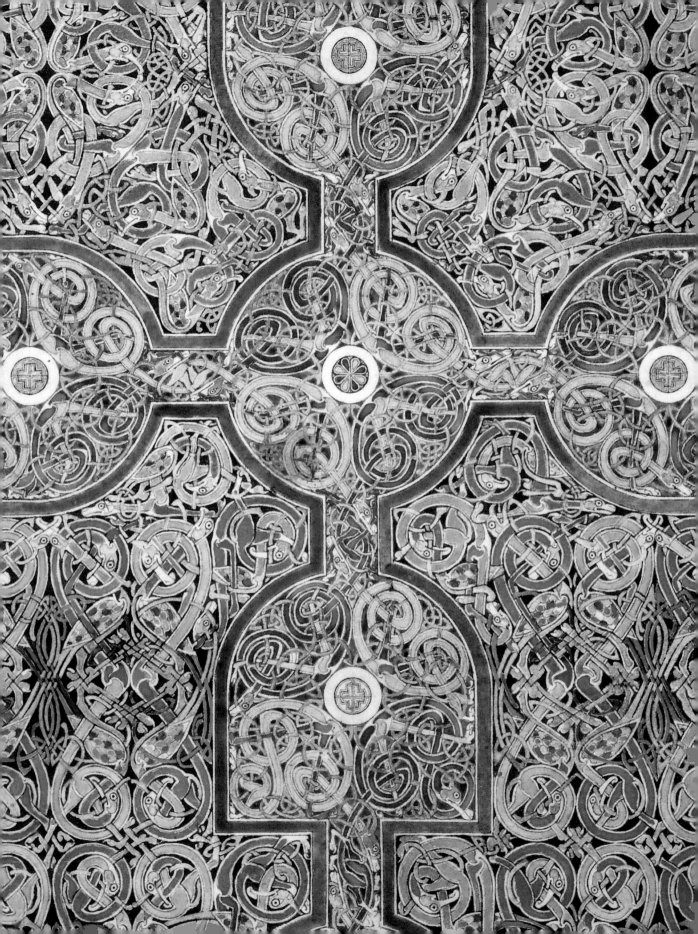

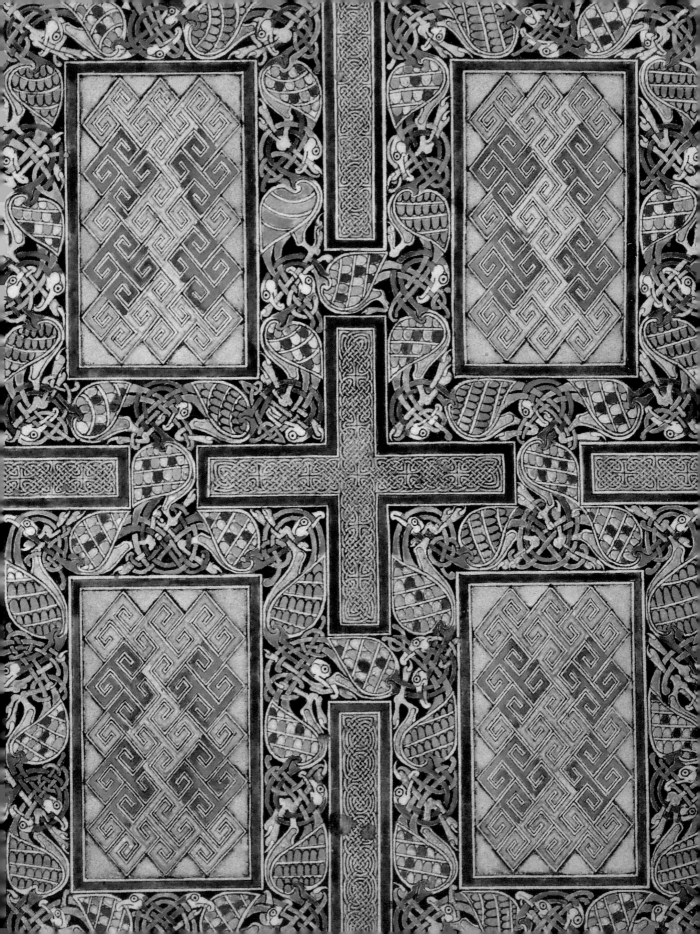

upper two quadrants the colours are mirrored, but in the lower quadrants and inside the cross the colours are reversed. There are also tiny unique details within the intricate web. For example, just one bird has an open beak and extended tongue, and just one beast has a shoulder joint articulated as a spiral. The impression is of overall harmony belying constant variation, a theme which has been linked to the idea of divine order guiding the vast and complicated universe.

By contrast, the carpet page of the Gospel of John (figs 38 & 46) produces its effect through the tension between the strict linearity of a grid of geometrical panels and the writhing energy of the interlaced birds crammed between them. The page centres on a panel in the shape of an equal-armed cross, outlined in red and containing dense yellow interlace reminiscent of finely crafted gold metalwork. This is surrounded by four T-shaped panels of interlace, four small square panels enclosing crosses, and four L-shaped panels containing curvilinear decoration, which form a larger cross-shape and a broken border around the central cross. Four rectangular panels, outlined in red and containing rectangular spirals of fretwork, occupy the quadrants. The space between these panels is filled with a procession of interlaced birds, biting and tumbling over one another into all the tight angles of the design as though trying to find their way around an endless maze. The colours of this page are particularly striking, with most of the page in soft shades of blue, pink, red and yellow, contrasting with a vibrant shock of bright green in the backgrounds of the fretwork panels. As in the St Matthew carpet page, there are unique details to spot: three birds whose shoulder joints are articulated as spirals, and one bird whose feathers are not delineated. The four rectangular panels between the arms of the cross call to mind the composition of a 'four symbols page', a feature of Insular gospel-books depicting the symbolic creatures of the four evangelists in the quadrants of a cross. A comparable example is found in another Insular gospel-book, the St Chad Gospels (fig. 39). A viewer who was familiar with such imagery and attuned to finding hidden meanings might perceive this design as an abstract version of a four symbols page.

There are clear links between the intricate designs of the Lindisfarne Gospels' carpet pages and the craft of the early medieval goldsmith. The sinuous interlaced animals combined with curvilinear decoration are mirrored on high-status metalwork from Ireland and areas of strong Irish influence,

[FIG.38] *Detail of the Gospel of St John carpet page (f. 210v).*

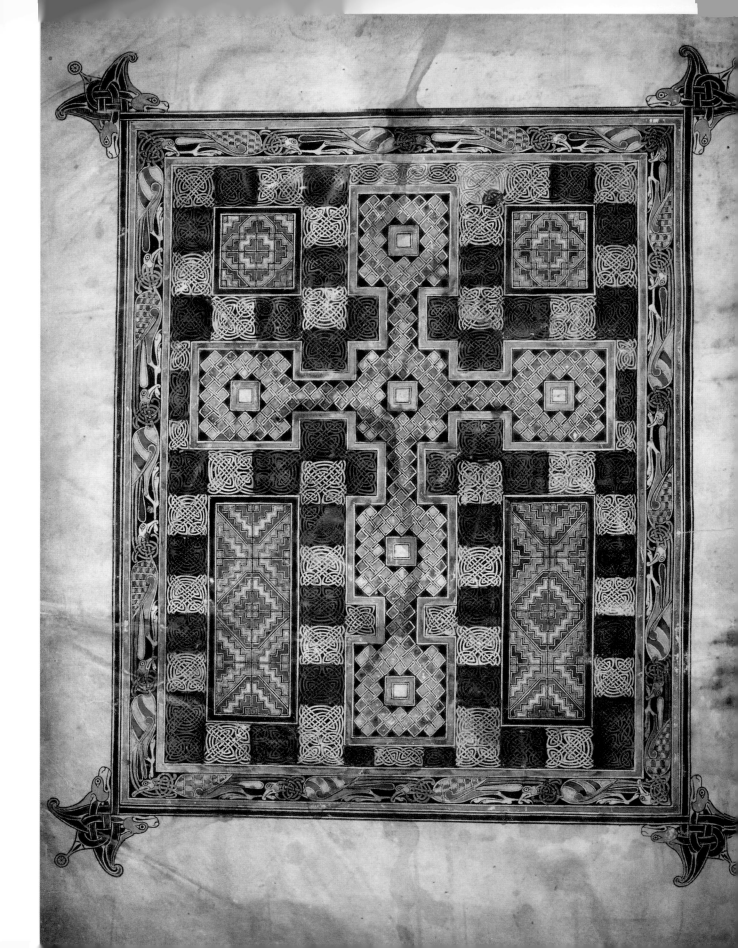

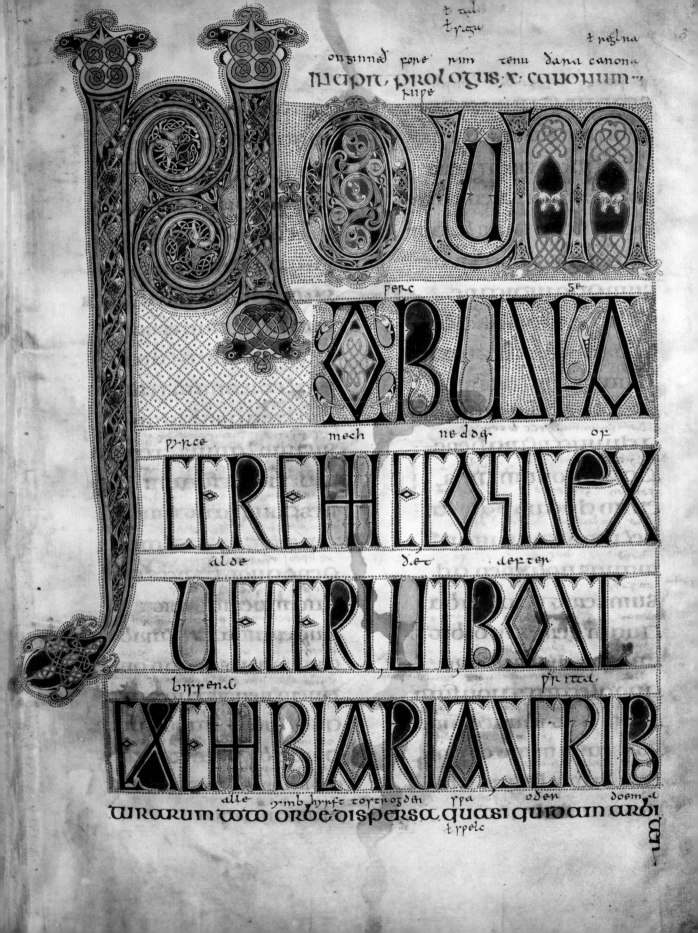

INCIPIT PROLOGUS X CANONUM

NOVM
OBUS
FEREMECOGISEX
VETERILIBAI
EXEMBLARIASCRIB
turarum toto orbe dispersa quasi quidam arbi

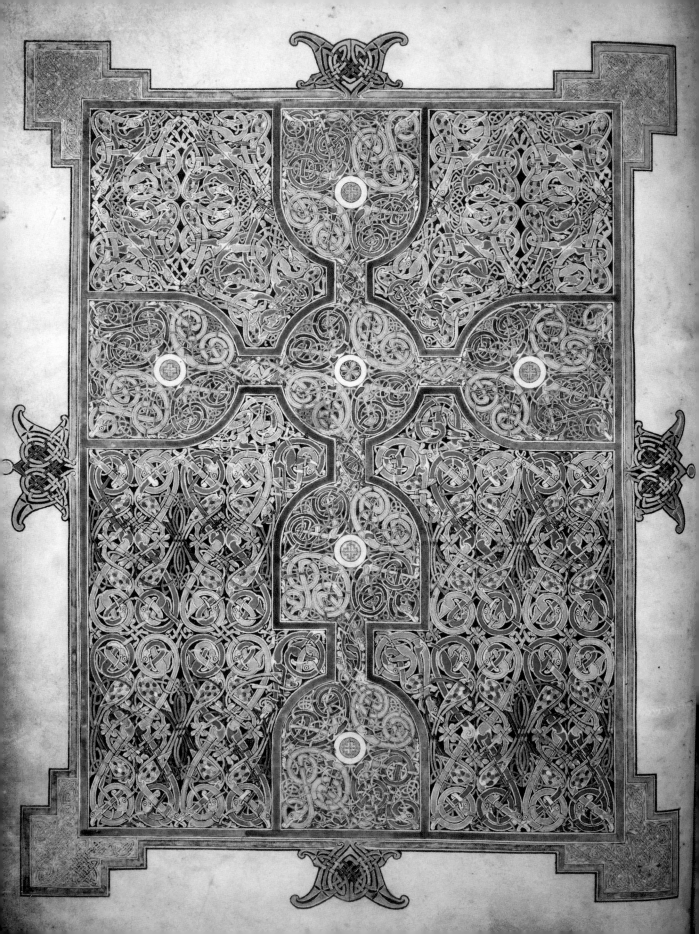

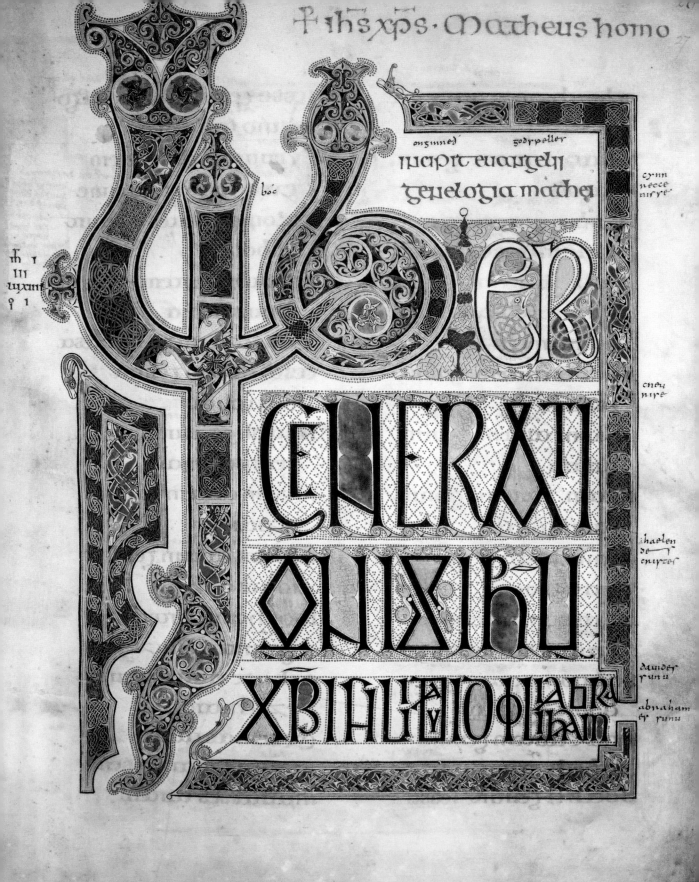

incipit euangelii
genelogia mathei

Liber
generationis
ihuxpi
filii dauid filii abraham

onginned godspeller
boc
mi
in
uy̆ant
oi
cynn
necce
niỹe
oncu
niỹe
ihaelen
de
eniỹtes
dauides
runu
abraham
es runu

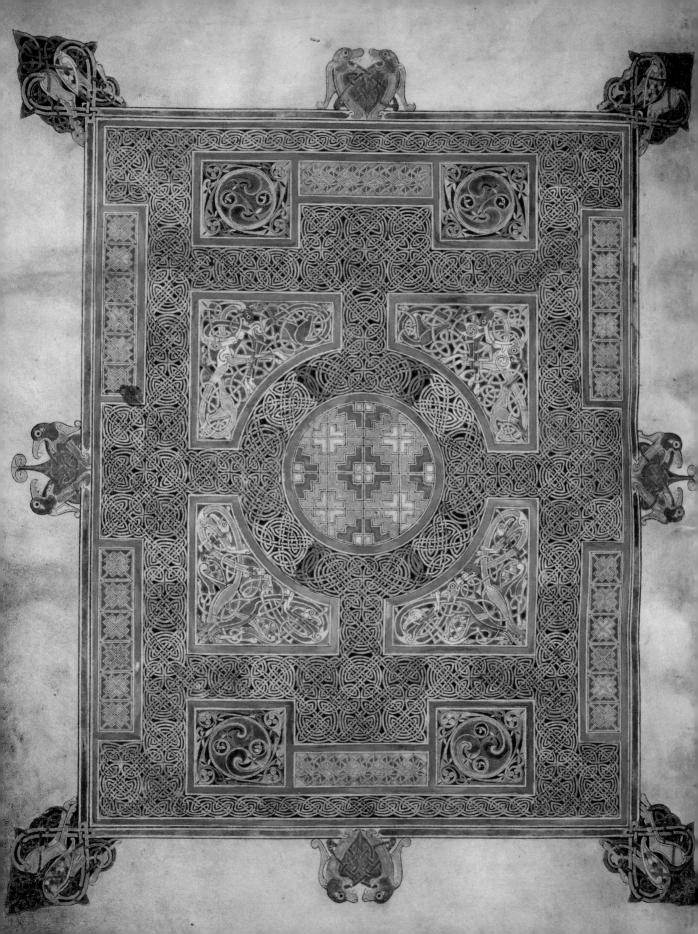

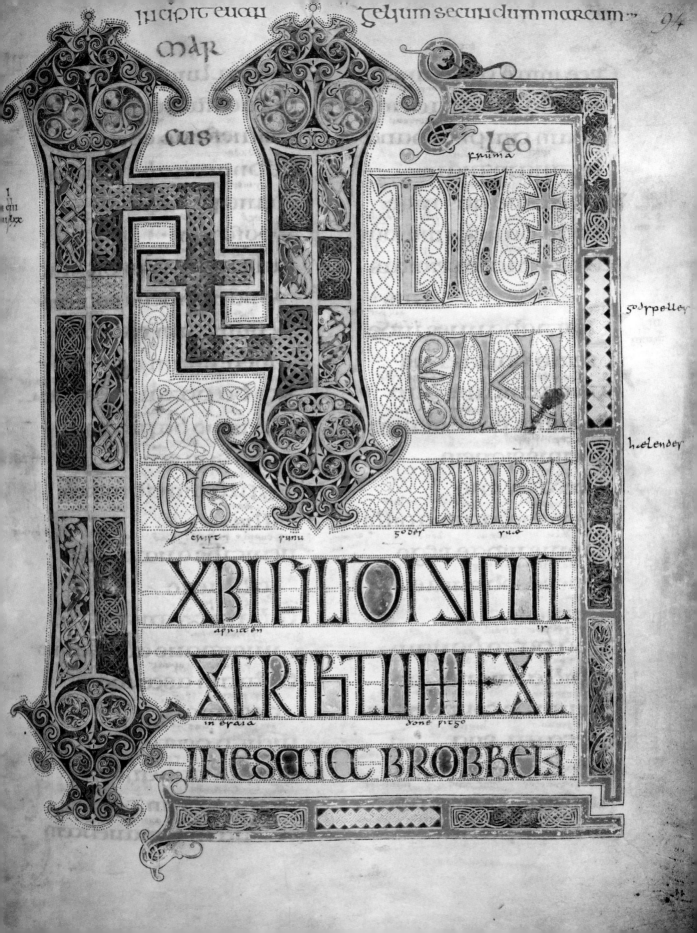

INIT
IUM
EUAN
GELII

XPI FILI DI

SCRIBTUM EST

IN ESAIA PROPHETA

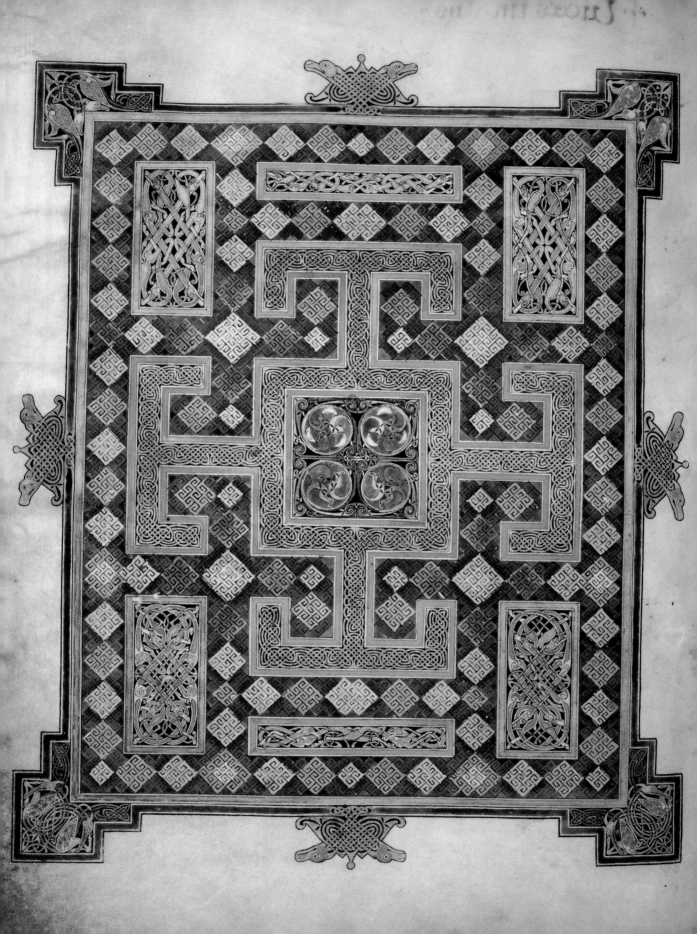

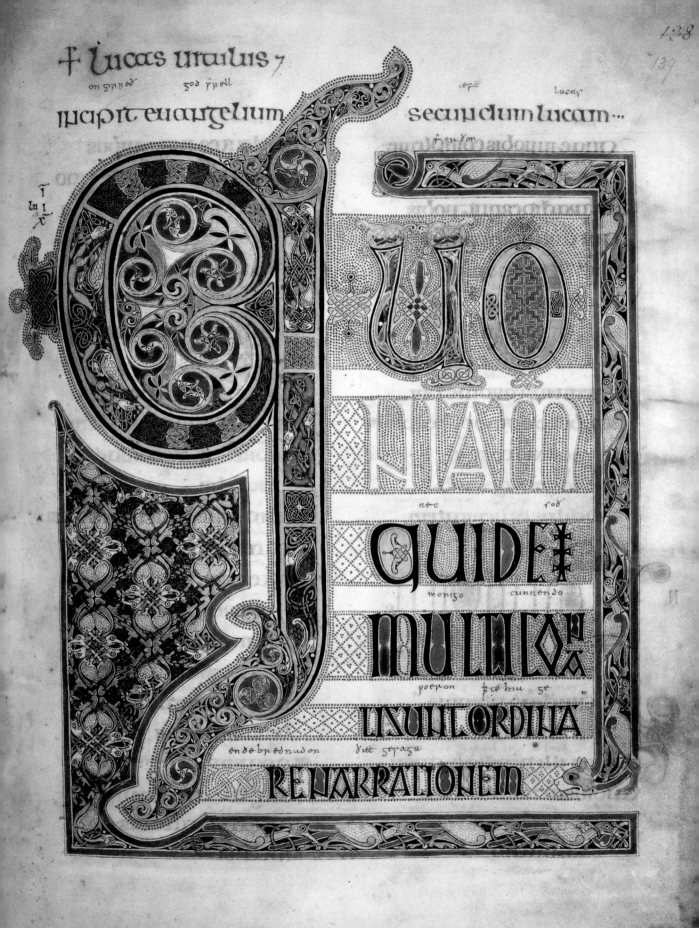

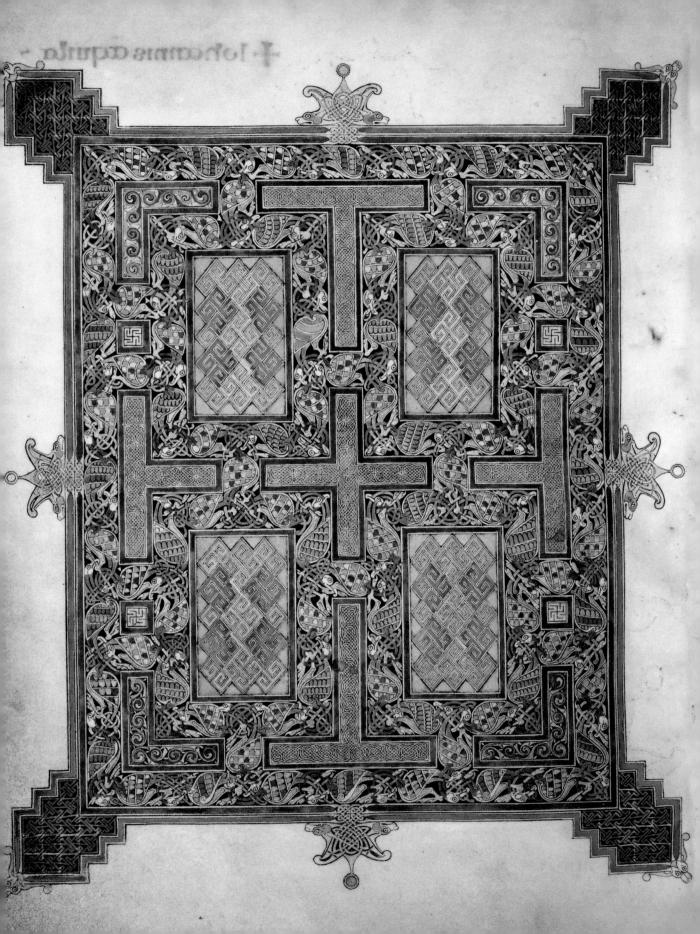

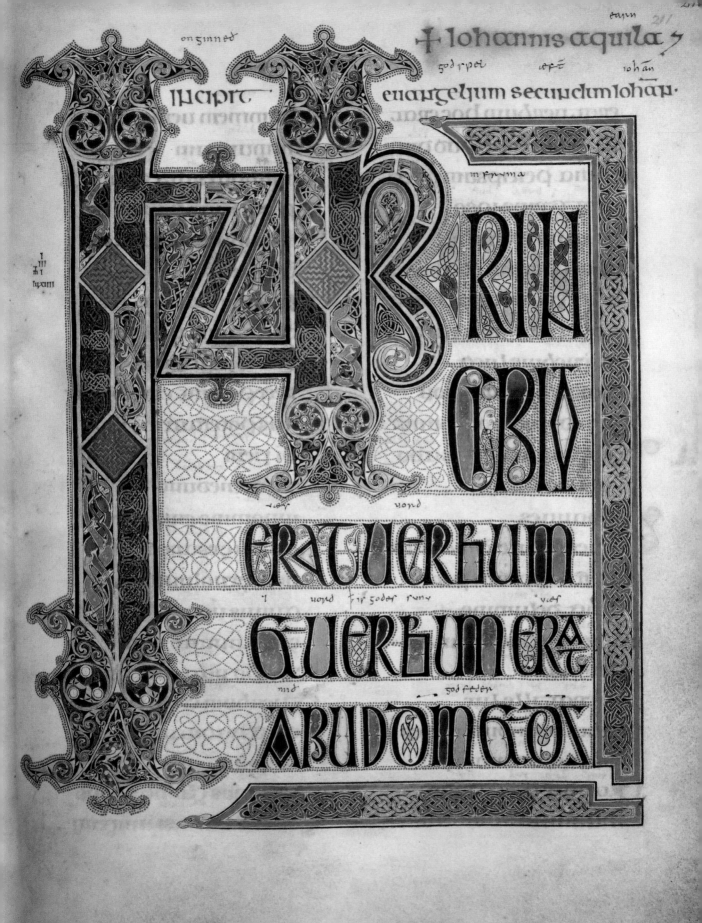

INCIPIT euangelium secundum Iohan.

IN PRINCIPIO ERAT UERBUM ET UERBUM ERAT ABUD DM ET DS

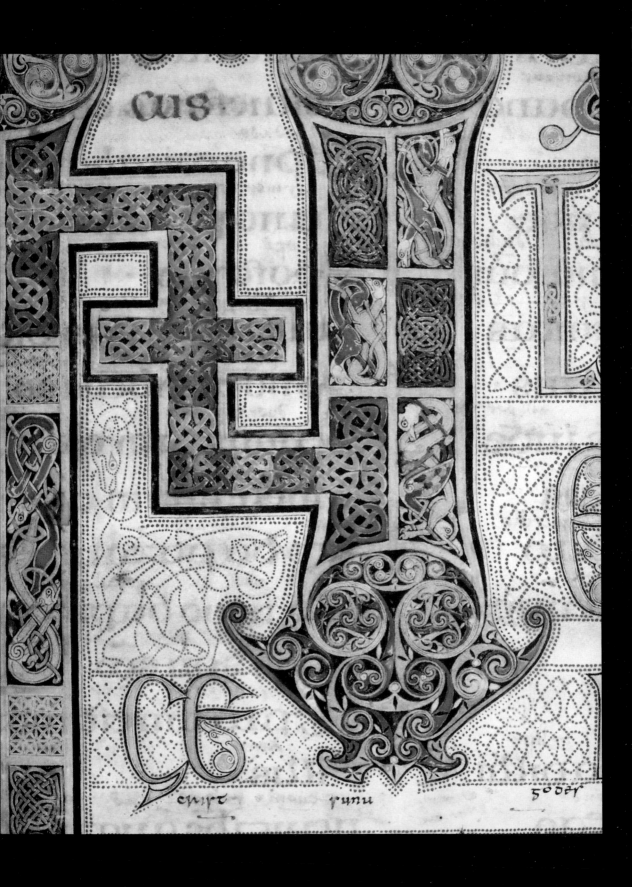

[FIG. 49, OPPOSITE] *Detail of the Gospel of St Mark* incipit *page, showing red dot designs including two entangled creatures (f. 95r).*

[FIG. 50, RIGHT] *Detail of the Gospel of St Luke* incipit *page, showing a big cat in the border (f. 139r).*

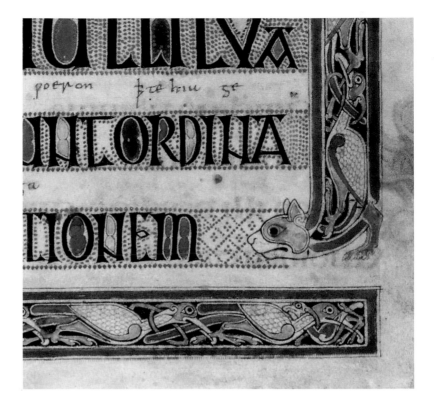

the lower end, the cat supports its weight on its flexed front legs and turns its head with interest towards the word *narrationem* ('story'). Its elongated body wraps around the text, and at the other end its hind legs curl around its back in an improbable knot. The cat's protracted belly is filled with a column of interlaced birds with hapless expressions. Was this a joke, or does it contain more serious symbolism? If the latter, the cat might represent the devil who devours sinners. Or, as in the ninth-century Irish poem known as *Pangur Bán*, the cat might parallel a voracious reader who hunts down meanings and feasts on texts. If the cat is actually a lion, it may refer to the lion symbol of St Mark (see p. 53). Or perhaps it symbolises Christ, whose resurrection by God the Father was compared with the legend that a father lion roars over its dead cubs to bring them to life.

Chi-rho and other initials

The beginnings of prefaces and some significant passages in the gospels are also marked with decorated initials, like smaller versions of those on the *incipit* pages (figs 24–29, 61). But one other page receives particularly special treatment – the *Chi-rho*

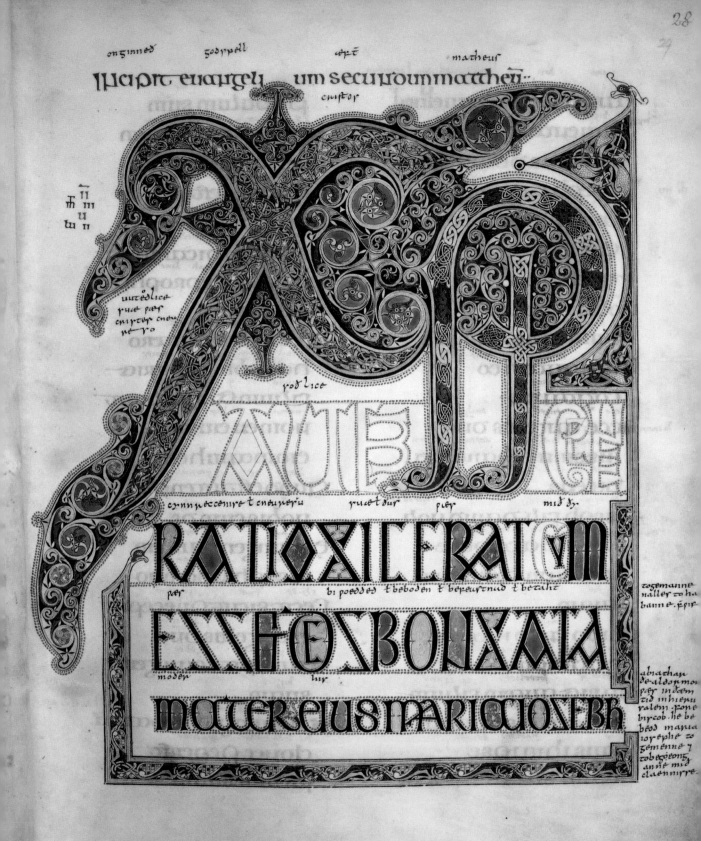

onginned godspell ept matheus

INcIpIT euangeli um secudumatthei..
 cnistor

matth
iiii
uii
uii

untedice
riæt pæs
enistes eneu
ne ro

godlice

cynn peccinire t eneuperiu ruce t dur pier mid dy

per bi poedded t beboden t bepertnud t betæht

togemanne
naller to ha
banne. epir

moden hir

abrachan
de aldopmon
per indem
tid inhiepu
ralem pone
bircob lie be
bead maria
iospht to
gemenne y
tob togeong,
antt mid
claen nyrre.

[FIG. 51] *The* Chi-rho *page (f. 29r).*

page (fig. 51). In Greek Bibles, the word 'Christ' was traditionally abbreviated to the letters *chi*, *rho* and *iota*, written as 'XPI'. A distinctive feature of Insular gospel-books is that, at the point where Christ's incarnation is first announced at Matthew 1:18, *Christi autem generatio sic erat* ('*Now the birth of Jesus Christ was in this way*'), the word 'Christ' is written as the Greek *Chi-rho* abbreviation and spectacularly magnified in the manner of a gospel *incipit*. The practice of abbreviating divine names, or *nomina sacra*, goes back to at least the second century, when letters representing the name of Christ were employed as Christian symbols. It was a way of showing reverence, making the *nomina sacra* stand out visually as more than ordinary words. The Greek letter *chi* was especially evocative because it is the shape of a cross, so it could signify both Christ's name as well as his crucifixion and its redemptive power. While all Insular gospel-books have an enlarged *Chi-rho*, the example in the Lindisfarne Gospels is one of the most spectacular. The insides of the letters are dense with knotted birds and interlace, while the outsides spin with an almost cosmic display of swirls. The letter *chi* looks as though it is leaping across the page on lithe legs, leaving trails of spirals in its wake – a jump for joy in honour of the incarnation.

THE STORY OF THE LINDISFARNE GOSPELS

CHAPTER 3

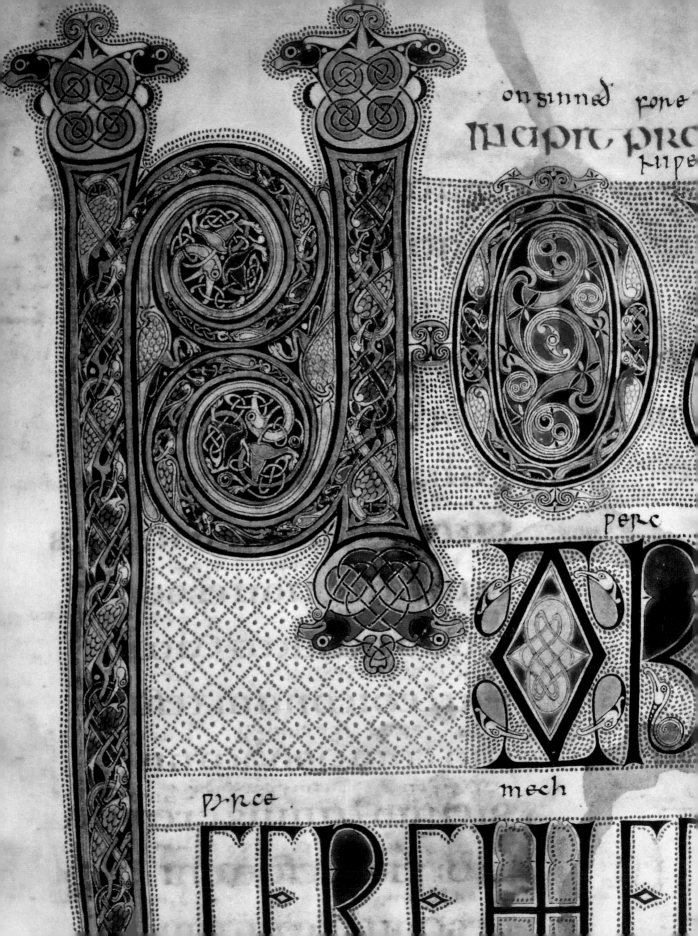

onsimned rone

incipit pro

hipe

pepc

pypce.

mech

The story of the Lindisfarne Gospels is tied to the fortunes of the monastery of Lindisfarne, the community of St Cuthbert, Durham Cathedral Priory, and thereafter the library of Sir Robert Cotton. At each stage in the journey of the manuscript, people have preserved it, made additions to it and recorded information about it. Its story is one of enduring significance and survival through the centuries in excellent condition.

Raiders from across the North Sea

By the end of the eighth century, Northumbria had passed the apex of its 'Golden Age' and the kingdom was beginning to fragment. The *Anglo-Saxon Chronicle* reports that the early months of 793 were marked by a series of frightening omens: lightning, whirlwinds and fiery dragons flying in the air. A terrible famine followed and then, on 8 June, 'heathen men' landed their ships at Lindisfarne and raided the monastery. They destroyed the church, stole a great number of its treasures and brutally killed many of the island's inhabitants. As the news quickly spread across Europe, people were shocked by the extreme violence of the raid and the targeting of an undefended religious centre, especially one of such pre-eminent fame and significance. Alcuin of York, a Northumbrian scholar based at the Frankish court, wrote a letter to the king of Northumbria deploring: 'the church of St Cuthbert spattered with the blood of the priests of God, despoiled of all its ornaments; a place more venerable than all in Britain is given as a prey to pagan peoples'. Yet the destruction cannot have been absolute, because the body of St Cuthbert together with its coffin and many of its treasures survived. The Lindisfarne Gospels and, according to later accounts, its treasure binding, also remained unharmed.

The seafaring pagan raiders who attacked Lindisfarne came from Scandinavia and are better known today as Vikings. In

[FIG. 52] *Detail of the* 'Novum opus' *preface incipit page (f. 3r).*

the decades following the assault on Lindisfarne, raiders repeatedly attacked settlements in Britain, Ireland and France, with Northumbria suffering especial depredation because of its relative proximity to Scandinavia. The monastery of Jarrow fell prey in 794, followed by Iona in 795, and soon these raids were happening with terrifying regularity. In 865 'a great heathen army' invaded East Anglia and the following year marched north, capturing the city of York on 1 November 866. It became the centre of the new Viking kingdom of York, from which the Scandinavian kings launched military campaigns into other areas. In 875, part of the heathen army, led by Halfdan Ragnarsson, made an expedition up the Tyne.

[FIG. 53] *A stone grave marker carved with seven armed men brandishing weapons, sometimes interpreted as a depiction of Viking raiders. It dates from the ninth century and was found on Lindisfarne (English Heritage).*

It is probably not a coincidence that in the same year the monks of Lindisfarne abandoned their island home, taking their possessions with them, including the remains of their most revered former bishops, St Aidan, St Cuthbert, Eadberht and Eadfrith. Separated from Lindisfarne, they became known as the Community of St Cuthbert. For a while they were itinerant, staying in various places around northern England and southern Scotland. At one point the members of the community decided to move to Ireland, but they were driven back by a storm, which they took to be a sign that St Cuthbert wished them to stay in England. Around the year 883, after several years of displacement, the community settled in Chester-le-Street, now in County Durham.

Chester-le-Street and new additions to the book

It was in Chester-le-Street in the 950s–60s that a priest named Aldred made some significant additions to the manuscript. He added an Old English translation of the gospels above the lines of the Latin text on almost every page in the manuscript. This has the distinction of being the earliest surviving translation of the gospels into the English language. It is a literal word-by-word translation, so the translated words do not form grammatical sentences. Rather than a text to be read on its own, it serves as

a guide for someone reading the Latin. To linguists, the text is additionally interesting because it provides a rare witness to the Northumbrian dialect of Old English in the tenth century. For a modern reader of English, it is fascinating to scan the lines of Old English, spotting the recognisable words among the ones that seem entirely obscure. To give a small flavour, here is Matthew 5:8:

Latin: *Beati mundo corde quoniam ipsi Deum videbunt.*
Old English: *Eadge biðon claene of hearte forðon ða God geseas.*
Modern English: *Blessed are the pure in heart, for they shall see God.*

[FIG. 54] *The words of Matthew 5:8 in Latin, with Aldred's Old English translation written above (f. 34r).*

Aldred also added the colophon that tells us much of what we know, or think we know, about the Lindisfarne Gospels (fig.55). A colophon, from the Greek meaning 'finishing touch', is an inscription at the end of a book providing extra information about it. The Lindisfarne Gospels' colophon is long and elaborate, written in a mixture of Latin and Old English. On account of his English translation of the Gospels, Aldred presents himself as one of the four men who contributed to the creation of the manuscript, paralleling the four evangelists who wrote the Latin text. After describing the transmission of the gospels from God to the evangelists, he states that Eadfrith, bishop of Lindisfarne, wrote the book 'for God and St Cuthbert and all the holy people who are on the island'; Æthilwald, bishop of the Lindisfarne, bound it; Billfrith the anchorite forged its precious metalwork cover; and he, Aldred, glossed it with the English translation.

While the Lindisfarne Gospels' colophon has often been taken at face value, some historians have questioned the credibility of an inscription that was added around 250 years after the Gospels were made. Perhaps Aldred and the Community of St

Cuthbert could have provided false information out of wishful thinking, or out of a desire to promote themselves by association with the prestigious history cited. There are other examples of medieval manuscripts with added inscriptions incorrectly claiming that they were written by holy figures; for example, the Book of Durrow (made around 700; now in the library of Trinity College, Dublin) has an inscription claiming that it was written by St Columba (d.597). Yet it is notable that none of the information in Aldred's colophon is demonstrably false, and much of it agrees with information in other surviving sources. All the people named in the colophon are attested elsewhere, living at dates that plausibly fit with the dating of the manuscript. They do not seem to be obvious choices upon which to base a fabricated tradition, since none of them is a saint, and Billfrith in particular is a surprisingly obscure figure to note. Some scholars suspect that the information in Aldred's colophon was based on an earlier inscription recording Eadfrith, Æthilwald and Billfrith's contributions, perhaps written on a lost page or engraved on Billfrith's precious metalwork covers. It is impossible to be sure based on the surviving sources, but the balance of probability seems to weigh in favour of the evidence presented in the colophon.

From the Middle Ages to the Reformation

Following its period at Chester-le-Street, the Community of St Cuthbert relocated again to Durham, its final home, in 995. In 1083, William de St-Calais (d.1096), Bishop of Durham, reformed the Community as the Benedictine Priory of St Cuthbert, also known as Durham Cathedral Priory. Several years later, he ordered the construction of the new Romanesque cathedral and monastic complex that still stand in Durham today. The remains of St Cuthbert were moved to a shrine at the high altar in 1104.

Symeon of Durham, a monk at the Priory in the early twelfth century, wrote a history of the community in which he described a precious gospel-book with a gold and jewelled cover which was preserved in the Priory church. He echoed Aldred's colophon in explaining that it was written by Eadfrith with his own hand in honour of St Cuthbert, and that Billfrith adorned it with gold and gems at Æthilwald's request. This account differs slightly from that given by Aldred, perhaps reflecting an independent tradition about the manuscript's

[FIG. 55] *The final page of the Gospel of St John, with the colophon added by Aldred in the tenth century (f. 259r).*



DICIT EIS IHS SIC EUM

UOLO MANERE DONEC

UENIAM QUID ADTE

TU ME SEQUERE

EXIUIT ERGO SERMO ISTE

IN FRATRES QUIA

DISCIPULUS ILLE

NON MORITUR

ET NON DIXIT EIS IHS

NON MORITUR

SED SIC EUM UOLO MARE

DONEC UENIO

QUID ADTE

HIC EST DISCIPULUS

QUI TESTIMONIUM

PERHIBET DE HIS

ET SCRIBSIT HAEC

ET SCIMUS QUIA UERUM

EST TESTIMONIUM EIUS

SUNT AUTEM ET ALIA

MULTA QUAE FECIT IHS

QUAE SI SCRIBANTUR

PER SINGULA

NEC IPSUM ARBITROR



MUNDUM CAPERE EOS

QUI SCRIBENDI SUNT

LIBROS · AMEN ::

EXPLICIT LIBER

SECUNDUM

IOHANNEN :

+ Trinus et unus dominus euangelium hoc ante scripsit

+ Matheus exore xpi scripsit

+ Marcus exore petri scripsit

+ Lucas deore pauli aps scripsit

+ Ioh inprochemio deinde enucuauit uerbum do donante

+ Eadfrid biscop lindisfearnensis ecclesiae...

(Old English colophon of Eadfrith, Æthilwald, Billfrith and Aldred)

+ Eadfrid . oediluald . billfrid . aldred . hoc euangelium do & sce cuðberhto construxerunt vel ornauerunt

+ Trea me pandat sermonis pda ministra Omnes almes meos fratres uoco raluta

manufacture, or a misreading of the colophon. Nonetheless, it seems very likely that this was the Lindisfarne Gospels. Symeon also recounted a legend that this gospel-book was swept overboard in the storm when the community attempted to sail to Ireland, and that it was later recovered from a beach miraculously unharmed. This parallels other miracle stories of books retrieved intact from water, including the gospel-book of St Margaret of Scotland (d.1093) described in a biography that was composed at Durham Priory around the time that Symeon was writing. It is certainly the case that the Lindisfarne Gospels contains no physical indication that it was ever in water.

There is no certain evidence of the whereabouts of the Lindisfarne Gospels for the remainder of the Middle Ages. There is a reference to 'the book of St Cuthbert that fell into the sea' in a list of books at Lindisfarne Priory in 1367, and then again in an account of books that were kept at Durham Priory in the 1530s. There is also a very brief record of seven gospel-books, five of which had precious metalwork bindings, kept at the shrine of St Cuthbert in Durham Cathedral in 1383. Some of these are probably among the remarkable collection of early manuscripts that survive in Durham Cathedral Library today.

At the end of 1539, Durham Priory was closed during the Dissolution of the Monasteries by King Henry VIII, and the church became an Anglican cathedral. The king's commissioners seized treasures from St Cuthbert's shrine, ripped open the tomb with a sledgehammer and broke one of the saint's legs, before removing his body to the vestry. The body was later reburied where the shrine had once stood. Yet it seems that the commissioners did not despoil the tomb thoroughly. Many of the treasures kept with the saint's body survived, including his wooden coffin, his gold and garnet pectoral cross, the gold and sapphire ring said to have been found on his finger, and the St Cuthbert Gospel (fig. 57). The preservation of these artefacts may partly result from the relatively high degree of continuity at the new cathedral, since some of the monks remained to form part of the staff,

[FIG. 56] *The shrine of St Cuthbert in Durham Cathedral today (Alamy Stock Photo).*

[FIG. 57] *The St Cuthbert Gospel, the earliest European book with an original, intact binding, made at Wearmouth-Jarrow in the early eighth century, found in the coffin of St Cuthbert at Durham Cathedral (British Library, Add MS 89000).*

including the prior, Hugh Whitehead (d.1551), who became its first dean in 1541.

Into the modern age

The Lindisfarne Gospels resurfaces in the historical record in the early modern period. In the 1560s, it was one of the sources used by Laurence Nowell in compiling the first modern dictionary of Old English. By 1605 it belonged to Robert Bowyer, Clerk of the Parliaments and Keeper of the Records, a known book collector who lived in the Tower of London. By 1613 it had passed to Sir Robert Cotton (d.1631), who amassed the greatest manuscript collection of post-Reformation England. Cotton's library was housed in a series of bookcases, each surmounted by the bust of a Roman emperor or imperial lady. The Cotton manuscripts

are still identified by reference to their placement on these bookcases, with the Lindisfarne Gospels bearing the shelfmark Cotton MS Nero D IV.

The Cotton library was transferred to the nation by Sir John Cotton (d.1702) and confirmed in a 1701 Act of Parliament. In 1731, a terrible fire damaged many of the books in the collection while it was stored at Ashburnham House in Westminster, but thankfully the Lindisfarne Gospels survived unscathed. The British Museum was founded by an Act of Parliament in 1753, with the Cotton library as one of its foundation collections.

In 1853 the Lindisfarne Gospels was furnished with a new treasure binding in a Celtic-revival style (fig. 58). The medieval binding said to have been made by Æthilwald and covered with gold and gems by Billfrith had long since vanished. The last evidence of its existence was apparently Symeon's description in the early twelfth century. The record of gospel-books with metalwork bindings at St Cuthbert's shrine in 1383 is another possible reference. The precious binding may have fallen victim to the royal commissioners when they dissolved Durham Priory in 1539, but there is no record of when it was separated from the manuscript.

A new binding was funded by Dr Edward Maltby, bishop of Durham (d.1859) and created by Messrs Smith, Nicholson and Co., silversmiths of Lincoln's Inn, London, at a cost of 60 guineas. It features silver gilt covers with precious stones in a design inspired by the carpet pages in the manuscript (e.g. figs 44 & 45).

The British Museum's Department of Manuscripts was transferred to the British Library upon its creation as the national library of the United Kingdom in 1973. The Lindisfarne Gospels is regularly on display in the Library's Sir John Ritblat Treasures Gallery, and has also featured in several temporary exhibitions at the Library. It has been loaned for display in Durham in 1987 and 2013, and in Newcastle upon Tyne in 1996, 2000 and 2022. The manuscript has also been fully digitised to make it freely available on the British Library's website for study and enjoyment by everyone.

A book for all times

One of the striking features of the Lindisfarne Gospels is its melding together of elements from disparate cultural traditions in a seamless and harmonious way. As such, it reflects the meeting of traditions in seventh- to eighth-century Northumbria,

[FIG. 58] *The modern binding created for the Lindisfarne Gospels by Messrs Smith, Nicholson and Co., silversmiths of Lincoln's Inn, London, in 1853.*

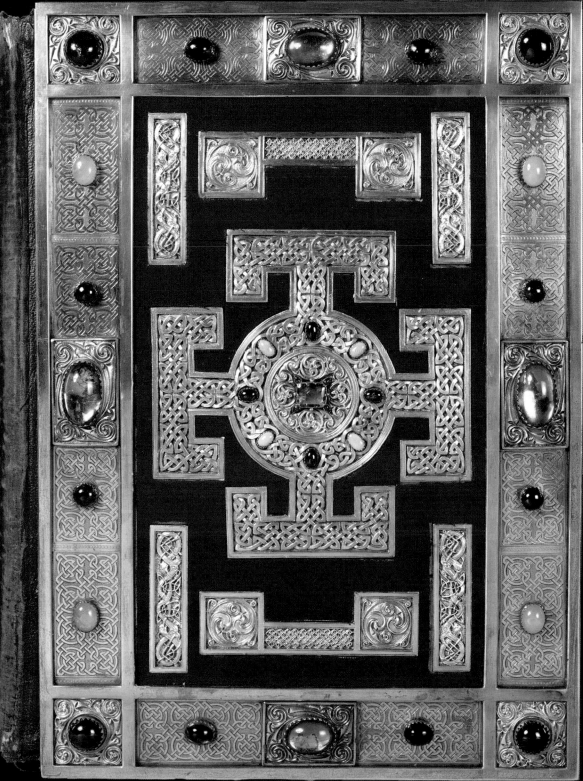

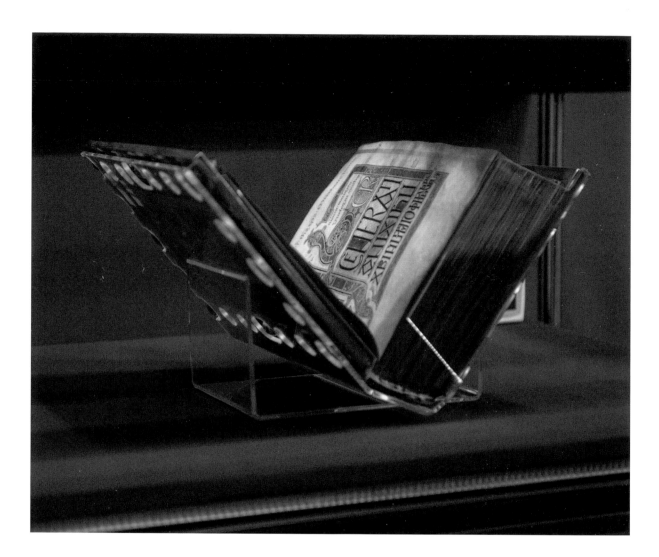

[FIG. 59] *The Lindisfarne Gospels on display at the British Library.*

with influences coming in from Ireland, Scotland, southern England, continental Europe and beyond. This all-embracing approach to cultural influences might also have been a very deliberate statement of Lindisfarne's identity as a community with a mixed heritage. Even after Lindisfarne adopted Roman practices following the Synod of Whitby, it continued to maintain close links with Iona and Ireland, and preserved a strong sense of its roots. Perhaps the synthesis of elements in the Lindisfarne Gospels can be interpreted as a way of celebrating the community's identity as an institution that embraced mixed traditions and hoped to bridge divided factions – a manuscript that could truly claim to be 'for God and St Cuthbert and all the holy people who are on the island'.

Centuries later, the Lindisfarne Gospels continued to help people define their sense of identity. The Community of St Cuthbert, disconnected from its original holy site and faced with the perilous political landscape of Viking-age Britain, was able to maintain its prestigious position through emphasising historic continuity with the monastery of Lindisfarne and its saintly patronage. In this context, Aldred wrote the colophon which emphasised the central importance of the manuscript to the community's history, also writing himself into that history in the process. For Symeon of Durham too, the manuscript was a vital connection between Durham Cathedral Priory and the earlier history of the Community of St Cuthbert, to the extent that it had become the subject of miracle stories.

The Lindisfarne Gospels continues to provide a focus for pride and identity which resonates with everyone. Its story connects us with the past, and its spectacular artwork has the power to affect us, provoking awe, inspiring creativity or nurturing spirituality. Perhaps most of all, looking at the Lindisfarne Gospels allows us a glimpse into the mind of its brilliant creator, who lived over 1,300 years ago and whose compelling vision of beauty still moves us to this day.

FOLLOWING SPREADS:

[FIG. 60] *Canon table comparing unique passages in the gospels (ff. 16v-17r).*

[FIG. 61] *Preface and chapter lists to the Gospel of St Matthew (ff. 18v-19r).*

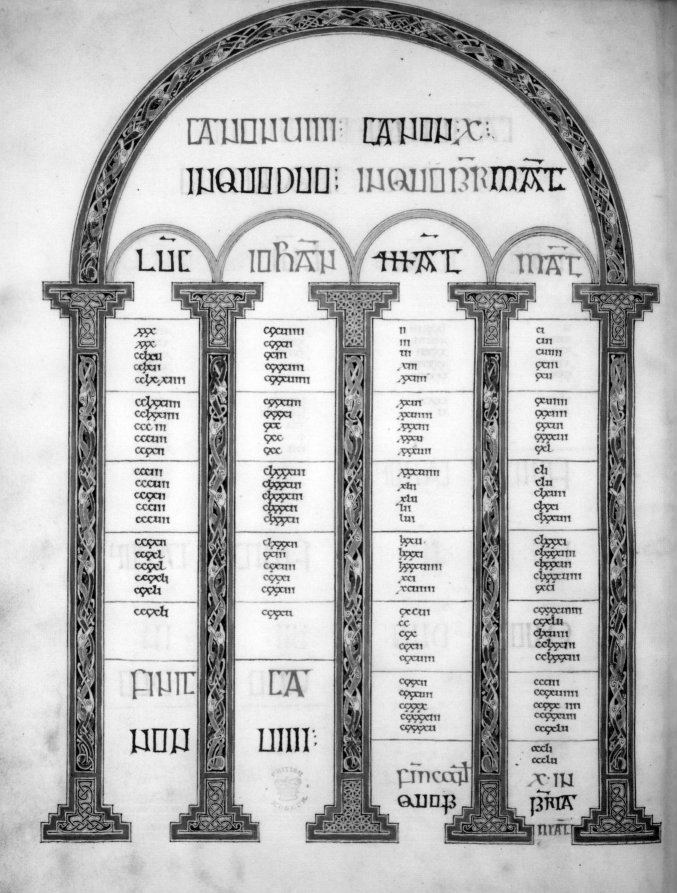

MĀR CANON DELIMUS
BROB INQUO BROBRIA LŪC

MĀR.	LUCAS	LUCAS	LUCAS
xxIIII	I	ccIII	cccIII
xxxI	III	ccxII	ccI
xLII	U	ccxIIII	ccII
xLIII	IIII	ccxxI	ccIIII
LIII	xcIII	ccLII	ccc
bxI	xx	ccLIIII	cccIII
bxx	xxII	cLI	cccxII
bxxIII	xxIIII	cLIII	cccxxI
bxxxI	xxxI	cLIIII	cccxxI
bxxxIIII	L	cLxII	cccxxI
xc	b	cLxIII	cccLII
xcIII	bxII	cLxII	cccLII
cI	bxIII	cLxIII	ccLxIII
cIII	bxxI	cLxxIIII	ccLxxI
cxxIII	cIIII	cLxx	ccLxII
cxxxI	cIII	cLxxII	ccLxxI
cbxII	cIII	cxxxII	ccLxxxII
ccxII	xcII	ccc	ccLxxxIII
	cccIII	cccIIII	cccxxIII
	cccxIII	cccc	cccxxxIII
	ccI	cccxIII	ccLII
	cccII	cccxxI	

FINIT
BRO
BRIA
MARCUS.

FINIT
BRO

CANX
BRIA

INQH
LŪC

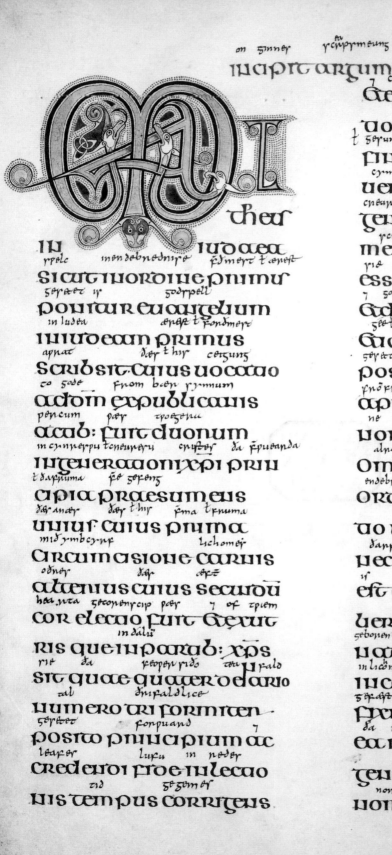

7 conehyrip in oper faent op geong

ᴁ ELECTIO INTRANS INTRA
 pd
 of rceader

VOBIS USQ: INXPM DE
7 gerundnay ennnez trimbgeong to

FILIENS DECURSUM AD
cyme duhener æ eager

VERTUS DNI OSTENDIT
cneuneyu þ 7 getal

GENERATIONEM UT GNU
 reiper 7 tider

MEROS TATUS ᴁ TEMPORIS
 yie þ yene æ aqued

ESSE QUOD ESSE OSTENDER
7 goder inhim uene ge epde

ᴁ DI IUSEOPUS MONTRAT
gee ecyod dana cynn

ᴁ UAM QUONUM TELLUS
gyete cnyer pncende

POSUIT XPI OPERATUS
ynenyra cydnegra 7 ger enerra

A PRINCIPIO TESTIMONIU
ne onyoc dana

VON EGARE QUANUM
alna dinglycewiza tid

OMNIUM RERUM TEMPU
endebnedmye tal gercead

ORDO NUMERUS DISPOSI
oette pehenyy þ luyer

TIO VEL RATIO QUOD PROE
danplic tned ly god cnyst

NECESSARIUM EST O XPS
iy ge geponden ly ynd pyfe

EST QUI FACTUS EST EXINU
 geponden unden ae

VERE FACTUS SUB LEGE
gebonen 7 gecenned op highstalo ge yroued

NATUS EXVIRGINE PASSUS
in lichoma alle mnode

IN CARNE OMNIA IN DUCE
gepastnade þ ·hegeygyestnade

FRET UT TRIUMPHANS
da in him ycolyeum ept anas

ᴁA IN SEM IPSO RESUR
in lichoma 7 padner

GENS IN CORPORE ᴁPAQUIS
noma mfadnum dem yunu

VOMEN IN PATRID: FILIO

theu

IN IUDAEA
rpelc mendebnedmye fdmert t enest

SICUT INORDINE PRIMUS
gereet iy godyrpell

PONITUR EUANGELIUM
in ludea epnge t fondmeye

INIUDEAM PRIMUS
apnat dey thy cetgung

SCRIBSIT CUIUS UOCATIO
to gode from bien yymum

AD DM EX PUBLICANIS
peneum per tyoegeu

ACTIB: FUIT DUONUM
in cynnerpu tcneuneyu cnyter da fpuanda

INTELLERATIONI XPI PRIU
t dagnuma fe gerens

APIA PRAESUM EIS
dey ancer dey thy yma tenuma

UNIUS CUIUS PIUMA
mid ymbeynz lychomey

CIRCUMCISIONE CARNIS
odney dey æpe

ALTERIUS CUIUS SECURDU
hea ita geeonenyeu per 7 of tpiem

COR ELECTIO FUIT ᴁEXUT
 in dalu

RIS QUE IN PATRIB: XPS
rie da reopey rido teu y palo

SIT QUAE QUATER DECARIO
 tal dupaldlice

NUMERO TRI FORMITER
geytet fonyuand

POSTO PRINCIPIUM AC 7
leayer luyer in neder

CREDENDI FIDE IN LECTIO
 tid ge gemey

NIS TEMPUS CORRIGENS.

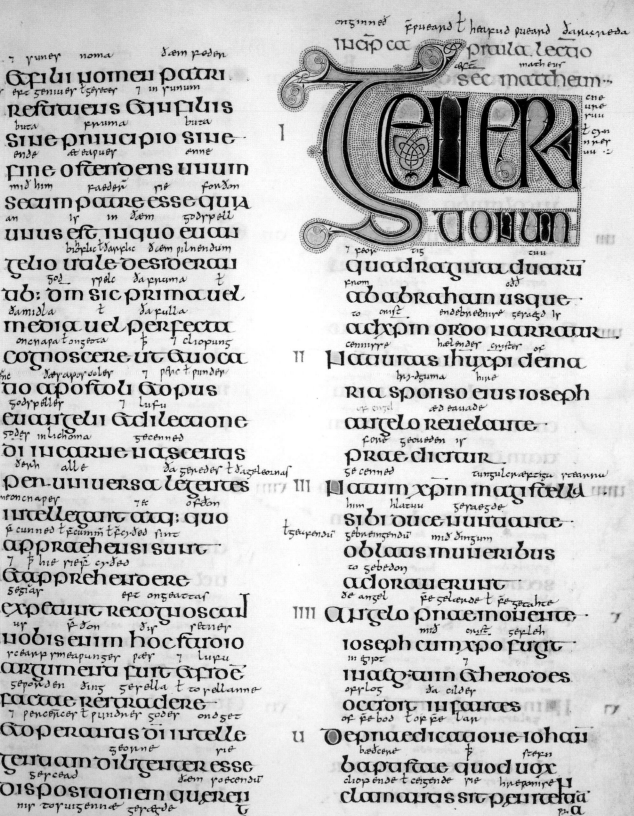

INCIP CA PIVLA. LECTIO
SEC MATTHEM

LIBER VOTVM

et fili nomen patri
restaturens et filis
siue principio siue
fine ostendens niuum
secum patre esse quia
unius est in quo euan
gelio uale desidera
ut: dum sic prima uel
media uel perfecta
cognoscere ut euoca
tio apostoli et opus
euangelii et dilectatione
di incarne nascentis
pen uniuersa legentes
intellegant atq; quo
apprachensi sunt
et apprehendere
expetiuit recognoscal
nobis enim hoc studio
argumenta fuit ut scie
factae retradere
ad operatus di intelle
gentiam diligenter esse
disposicionem quaeri
uoluntaere explicit

quadraginta duaru
ab abraham usque
ad xpin ordo narratur
Natiuitas ihu xpi de ma
ria sponso eius ioseph
angelo reuelante
prae dicitur
Natum xpin magi stella
sibi duce nunciante
oblatis muneribus
adorauerunt
Angelo pnaemonente
ioseph cum xpo fugit
in aegiptum et
interim et herodes
occisis infantibus
De pnaedicatione iohan
baptistae quod uox
clamantis sit praeciata

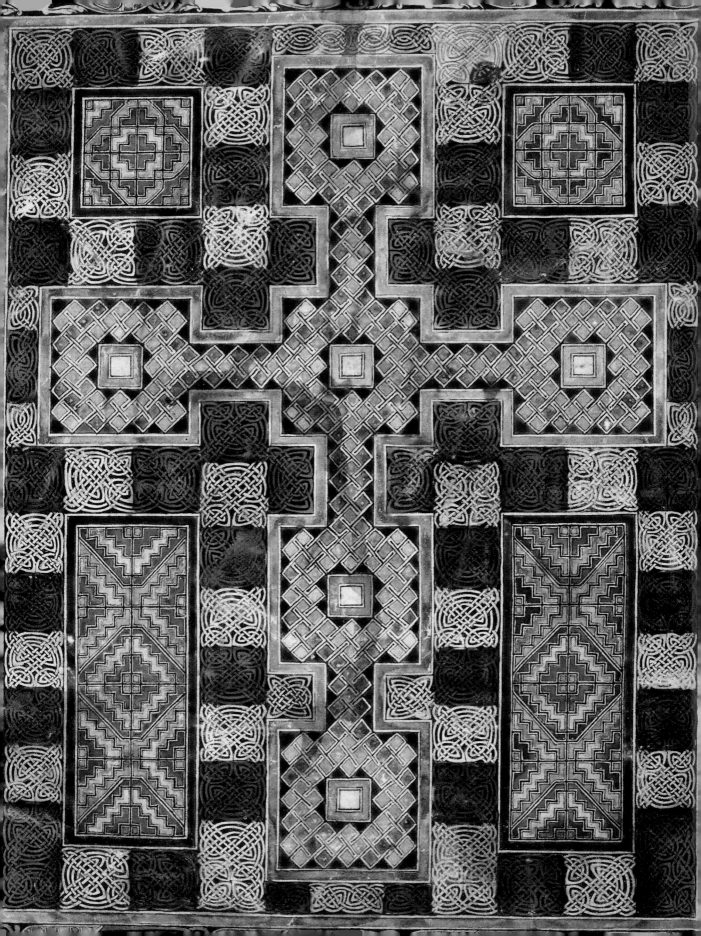

FURTHER READING

View the Lindisfarne Gospels online at:
www.bl.uk/manuscripts/FullDisplay.aspx?ref=Cotton_MS_Nero_D_IV

All Bible quotations from 21st century King James version.

Backhouse, Janet, *The Lindisfarne Gospels* (Oxford, 1981).

Bonner, Gerald, David Rollason and Clare Stancliffe (eds), *St Cuthbert, his Cult and his Community to AD 1200* (Woodbridge, 1989).

Breay, Claire, 'Exhibiting the Lindisfarne Gospels', in *An Insular Odyssey: Manuscript Culture in Early Christian Ireland and Beyond*, ed. Rachel Moss, Felicity O'Mahony and Jane Maxwell (Dublin, 2017), pp. 302–20.

Breay, Claire and Bernard Meehan (eds), *The St Cuthbert Gospel* (London, 2015).

Breay, Claire and Joanna Story (eds), *Anglo-Saxon Kingdoms: Art, Word, War* (London, 2018), no. 30.

Brown, Michelle P., *Painted Labyrinth: The World of the Lindisfarne Gospels* (London, 2003).

——— *The Lindisfarne Gospels: Society, Spirituality and the Scribe* (London, 2003).

Gameson, Richard, *From Holy Island to Durham: The Contexts and Meanings of the Lindisfarne Gospels* (London, 2013).

——— (ed.), *The Lindisfarne Gospels: New Perspectives* (Leiden, 2017).

Hawkes, Jane, *The Golden Age of Northumbria* (Morpeth and Newcastle, 1996).

Henderson, George, *From Durrow to Kells: The Insular Gospel-books 650–800* (London, 1987).

Kendrick, T. D. et al., *Evangeliorum Quattuor Codex Lindisfarnensis: Musei Britannici Codex Cottonianus Nero D.IV*, 2 vols (Oltun and Lausanne, 1956–60).

McKendrick, Scot and Kathleen Doyle, *The Art of the Bible: Illuminated Manuscripts from the Medieval World* (London, 2015), no. 2.

[FIG. 62] *Detail of the 'Novum opus' preface carpet page (f. 2v).*